Artists Handbooks
Art with People

edited by

Malcolm Dickson

a
PUBLIC

AN Publications

By giving access to information, advice and debate, AN Publications aims to:

- empower artists individually and collectively to strengthen their professional position
- raise awareness of the diversity of visual arts practice and encourage an equality of opportunity
- stimulate good working practices throughout the visual arts.

Series editor	David Butler
Reader	Clymene Christoforou
Proof reader	Heather Cawte Winskell (100 Proof)
Index	Susanne Atkin
Cover image	*Celebrating the Difference* by **Loraine Leeson** of Art of Change.
Design & layout	Neil Southern
Grant aid	Arts Council of England
Printer	Mayfair Printers, Print House, Commercial Road, Sunderland SR2 8NP

ISBN 0 907730 23 X

 AN Publications is an imprint of Artic Producers Publishing Co Ltd
PO Box 23, Sunderland SR4 6DG, tel 0191 567 3589

Contents

Contents

Examples

Contributors

FELICITY ALLEN
Felicity Allen is an artist and lecturer. She has exhibited widely, and carried out commisions and residencies. As well as lecturing in higher education she works in galleries, schools, hospitals and day centres. Formerly a lecturer at Winchester School of Art she was, until 1995, the first director of NAGE, the National Association for Gallery Education.

ADE BARRADEL
Ade Barradel was a director of Copy Art and resource centre worker for many years. He currently works with video and print and has produced his own music 'zine' *Fire'n'Skill*.

NICK CLEMENTS
Nick Clements married with two children and has lived and worked in South Wales since 1978. Founded the Pioneers and has been involved full time throughout its history; is a director of the company together with Sarah Osborne. They have provided employment for over fifty artists/craftspeople; worked throughout Wales, Britain, Germany, Norway and America; enabled the children from over 350 schools to produce art work.

SUE CLIVE
Sue Clive left art teaching fourteen years ago to work as a freelance gallery educationalist, primarily in the North West. She is now based in London, but works on research and consultancy all over the country, designing and leading gallery education training and outreach programmes and practical projects.

LEE CORNER
Lee Corner is an independent writer, researcher and arts coordinator. During 1994/95 she researched and wrote *A Code of Practice for the Visual Arts*, commissioned and published by the National Artists Asociation.

SEAN CUBITT
Sean Cubitt is senior lecturer in Media and Cultural Studies at Liverpool's John Moores University, and author of many papers on media and electronic arts. He is the author of *Timeshift: on Video Culture* and *Videography: Video Media as Art and Culture.*

MALCOLM DICKSON
Malcolm Dickson is a freelance cultural worker and independent organiser. He founded and edited Variant 'a magazine of critical cross-currents in art, media and ideas', and is currently the director of 'New Visions' international festival of film, video and media which occurs bi-annually in Glasgow. He is also on the organising committee of the Scottish Book Fair of Radical, Black and Third World Books.

5

Contributors

NINA EDGE

Primarily a visual artist, Nina Edge also participates in carnival and inter-disciplinary, perormance-based events. She has also worked in many aspects of education.

ADAM GEARY

Adam Geary is the Arts Officer at Maidstone Borough Council. He also continues to publish independently through Prolific Pamphleteer.

JULIETTE GODDARD

Juliette Goddard is a painter, printmaker and ceramicist. Besides developing a studio practice based in London and Switzerland she works in schools and teaches at Ormond Road Workshops.

DAVID HARDING

Since 1960 – executed public art works and developed community art practices; 63-67 worked in Nigeria; 68-78 Glenrothes Town Artist; 78-85 Senior Lecturer Art & Social Contexts, Dartington; 86 – Head, Environmental Art, Glasgow School of Art; Chair, Scottish Sculpture Trust; Founding Trustee of ASCENT and Little Sparta Trust.

PAUL HAYWOOD AND KAREN LYONS

Paul Haywood and Karen Lyons are artists in the North West. They were closely involved with 'Artists for the Environment in Rochdale' since 1986 and the 'Order Out of Chaos' network. They teach at University College Salford and have most recently joined forces with Kerry Morrison to form 'Art Interchange', an artists initiative in international exchange.

SUHAIL KHAN

Suhail Khan is a freelance, multi-media cultural worker and Director of Cultural Transmissions Network. He is extensively involved in developing new audiences for independent and mainstream art-based venues around the North West of England, and is working in collaboration with other agencies such as Accidental, Weaveworks and Hooch in developing a new on-line production agency.

RICHARD LAYZELL

Richard Layzell is developing *Tap Ruffle and Shave,* an interactive installation for the sensory impaired, in collaboration with an architect and an engineer. He has recently presented performances in London, USA, Canada and Poland. His *Live Art in Schools* was published in 1993. He is a senior lecturer at Wimbledon School of Art.

NICHOLAS LOWE

Nicholas Lowe is a visual artist who works in photography, installation and performance. He has worked in residence in health care and in prisons, and has exhibited widely in Europe. He is lecturing in Art and Social Context at UWE in Bristol, and is completing a PhD at UCE in Birmingham.

MARTIN LYNCH

Martin Lynch is a playwright living and working in Belfast.

ALISON MARCHANT

Alison Marchant is an artist working with audio-visual installations, developing work around working class histories from collaborations and interviews.

MARK PAWSON
Mawson has been an active book and photocopier artist and international postal art networker for the last ten years. Has recently written for *Modern Review* about television car commercials and a construction kit toys.

ALAN McLEAN
Alan McClean is a visual artist who has developed performance, photography and video work. He has curated events and led workshops in higher education and the community. Collaborations include Prison Audio Project with Nicholas Lowe and *Snoozyland* with Tony Mustoe.

SALLY MORGAN
Sally Morgan is Head of Art & Social Context at the University of the West of England. She first became involved in community arts in the seventies and was a member of the National Steering Committee of the Association of Community Artists. Current work is in live art and notions of contextualised practice.

ESTHER SALAMON
Esther Salamon is Co-Director of Artists' Agency. She has been involved with community theatre, music collectives, animation and video projects, community development work, youth work and has also been a child care officer, secretary, factory worker, cleaner and waitress.

GILLIAN STEELE
Gillian Steele is an artist working predominantly with film, and is interested in community art projects which take art and cinema outwith their conventional contexts.

STEFAN SZCZELKUN
Stefan Szczelkun took his vocation as a visual artist seriously late in life. Did a lot of performance and mail art in the eighties. Working class and immigrant identities surfaced as his key issues. Started self-publishing books "by and about working class artists" in 1987. Since then visual work has been driven underground by writing and research.

SUSAN TAYLOR
Susan Taylor is an artist working with photography and mixed media to make installations and wall-based works. She was a member of Open Hand Studios from January 1986 until June 1994 and is presently a Lecturer in Studio Practice in the Department of Fine Art at the University of Leeds.

MARY TURNER
Mary Turner is artistic director of Action Space Mobile, a community arts company that works with people of all ages. It also produces its own performances for outside and non-theatre venues. Her main areas of interest are environmental and historical which translate into textile wall hangings, shadow puppetry, stencils and live performance. Present one-person show, 'This Year, Next Year, Sometime, Always', draws materials from around the world with stories, objects and puppetry.

KEN WOLVERTON
Ken Wolverton is a muralist and performance artist based in New Mexico.

Introduction

Malcolm Dickson

"The notion of the abstract standard of excellence is seen as no more than the intellectualised publicity copy which attempts to present the commercialisation of the art of all ages, all opinions, all contexts, to all people. Behind the rigid maintenance of 'standards of excellence' which remain undefined and undefinable, there may well be concealed the unconscious fear that artistic expression will gain the power of popular meaning....

"The truth is that people make culture. They make it in towns and cities, in villages and hamlets, on housing estates and in suburbs.... It is to do with self-expression and social needs. It is active, not passive, it is neither a sub-culture nor an alternative. It is active and to be lived rather than passive and to be appreciated."

Artists and People,
Su Braden,
Routledge & Kegan
Paul, 1978

Contents

The basis of this book is a conviction that art can be used in a variety of situations as a socially relevant practice. This is based on a cross-section of examples which in many ways are broadening the idea of art as it is today by continuing to use it as a vehicle for personal, community and social development.

A fruitful lineage is suggested to the community arts movement of the seventies, but it is neither a history of that nor an overview of local arts being practised – the former requires volumes for the documentation to be comprehensively pulled together and the latter in need of constant updating. Unsatisfactory as the term 'community arts' may be (often used simply to demarcate a range of practices from the privileged world of the established arts), it is used here as a starting point for a re-evaluation that addresses the multifaceted ways in which the visual arts have developed across a number of initiatives and institutions. This has involved absorption, as much as adjustment and development by artists, with the challenge of shifting priorities in the arts and society as a whole. Although problematic and requiring

redefinition, 'community arts' is used as an umbrella term to describe a multitude of arts work which is grounded in community practice. It is also a way of thinking about the arts and their reintegration into an increasingly threadbare social fabric.

The contributions by artists and artsworkers in this book do not constitute an alliance or tendency for or against a particular approach in the framework of the arts as they manifest themselves presently. These are a set of practices where the working processes are opened up for consideration and debate. Self-initiated projects by artists are included in the book, as well as local authority supported projects, arts council commissions, short-term and long-term residencies, and the extended role for art galleries regarding the status of fine art education. Mapping 'histories' is crucial to legitimise the practice outwith its own practitioners, enthusiasts and participants and some historical context is provided, hopefully giving a sense of the trajectory community-based arts practice has taken in often turbulent conditions.

The book is intended to be of use to artists and arts organisations intending to work in these areas, to those planning to commission such projects, to funders involved in national policy formulation, and to the many others whose roles come into play and who might conventionally be considered only to function as audiences and recipients for the work of artists. It is not suggesting that the examples are a formulation of a new relationship for art in social contexts, but that they are part of a continuum that should now be perceived to be central to the functioning of the arts in the islands of the UK today. A discontent with things as they are may be said to link all the contributions. Intentions and purposes may differ, but they are all united around a social concern and an art practice that gives – or potentially gives – shape to other people's creativity, that involves partnerships with 'non-artists' and consultation with other bodies than those within the arts sector.

The role of the artist

The arts have many social, critical and practical functions: these can be in fostering self-confidence, in skills sharing, in facilitating communication, and in personal as well as community enhancement. These are often missing from a traditional training in the arts, despite the fact that many artists who manage to continue to produce will find themselves in some workshop situation at one point or another and be expected to inspire and communicate for a couple of hours before returning to the sanctity of pure practice. On a practical level, the arts help in bringing people together and

enriching the quality of life, sometimes only briefly, sometimes more enduringly over a very long time.

"To be involved in creating works of art allows us the opportunity to be involved in the production of work with a point and layers of discoverable meaning. This is not an empty display of artistic temperament or virtuosity or a form of crime prevention or a means of occupying leisure time. This is a process of working towards a sense of the world, conceiving ideas and carrying these out without necessarily using numeracy, literacy or logic. Contemporary community art can make accessible a full range of possibilities with regard to meaning, modes of expression, interpretation, and the right to informed choices which lead to creative thought and action."

'Taking Turns',
Christine Wilkinson,
Mailout, February/
March, 1994

The background theory of *Arts and Communities* published in 1992 is that the arts enlarge people's imaginations and extend their ability to communicate. "Social concern is present in every artist but in arts in the community it is fundamental.... In the last twenty years the relationship of the arts to local communities has been pursued in a variety of ways: extending the reach of traditional arts to a wider social spectrum; helping people in particular communities to develop their own arts skills and forms of expression; giving greater recognition to the arts of particular ethnic, cultural, social or occupational groups; and developing critiques of traditional avant-garde or popular arts."

Arts and
Communities,
Community
Development
Foundation, 1992

Factors of social concern and participation distinguish this from the work of the fine artist who works solely through the gallery system. It incorporates a diversity of activities, stemming from a range of sources, through different institutions and facilitating structures.

The issue of taste

Artforms in the mainstream art world are defined narrowly, and that is tied up with a narrow definition of quality which many see as intentionally structured in order to protect certain interests. The institutions of the art world are built upon and are riddled with class bigotry, a prejudice often reciprocated. This duality becomes a situation of dominance and subordination where those in power can materially validate certain art forms according to subsidy whilst devaluing others by denying it.

Community, Art and
the State: Storming
the Citadels, Owen
Kelly, Comedia, 1984

"Art is an ideological construction; a generalisation which has a complex history though which its meaning has both shifted and narrowed. In its current usage its chief purpose is to bestow an apparently inherent value onto certain activities and the products resulting from these activities, while withholding this value from

certain other activities. In this respect the term 'art' functions as one of a series of categories whose purpose is to assist in the construction and maintenance of a hierarchy of values which, having been constructed, can be made to appear as both natural and inevitable.... The process by which this happens is profoundly political: it is not the result of impersonal market forces, nor is it the outcome of a series of historical accidents. It is the result of some groups being more powerful than others; of some groups being in the position to gain access to the levers of power which is denied others....

"The term 'art', then, does not describe a set of activities, but a framework within which certain activities are placed, and the distinctions which are maintained between 'art and non-art' are part of the dominant structures of our social organisation."

Aesthetic appreciation is often a process of self-legislation which marginalises those who do not share the same tastes. This is protected by notions of 'standards of excellence' and by 'professionalism' which immediately cast out the increasingly important role played by the amateur arts, or the assessment of process, participation and consultation in qualitative terms. Far from being unimportant in arts work with people, quality and excellence are central to it. Certain fine art practices and high arts are protected from the yardstick which is used to measure more socially engaged arts. It has been easy for art world supremacists to dismiss whole areas of practice as 'social art' – seen as decoration, community work, art therapy or play. That it is not considered equal to those other 'proper' art forms which cater to a minority of tastes and to which the majority of funding goes deflects any challenges to the mainstream. The examples in this book illustrate that a concern for quality does not mutually exclude process and product, that art can be issue-based but not simply reduced to issues, can be innovative and make great creative use of many resources – and compensate uniquely for a lack of resources.

What community? And where?

The term 'community' can mean people living in a particular locality; having similar interests on a local basis; a community of interest which may be issue-based or around specific identities. Some of these communities of interest are inclusionary and some exclusionary. So the term does not describe any one thing, and its overuse does not help without consideration of those factors which complicate its use. In geographical terms, a community can be within a city or in a rural

setting – there are different social networks, friendship circles, modes of behaviour and methods of consumption of the wider culture, influenced by TV and radio. Explanation and dissemination of the arts range through local arts centres and galleries, community projects in towns and rural areas, to the more privileged access to culture in major cities served by national galleries, theatres and high profile touring events. Each situation has to be assessed on its own terms and subject to its own conditions, but the dynamic view of community is here adopted as one which increases the opportunities for wider sociability rather than dissolving them.

It is becoming more difficult to define any project on the basis of a shared interest when community is being corroded and social welfare destroyed. There are new poverty factors which have emerged in the eighties and which are based on exclusion from mainstream society: "the low paid, part-time workers, the homeless, the self-employed, physically and mentally handicapped, ethnic minorities, many pensioners, many people who are not registered as unemployed because they are occupied in full-time care", all of which "have a preponderance of women." The gap between the haves and the have-nots is becoming wider and this is being advanced by new technology. There is a growing sense of despair and a retreat into atomised activities that take place behind heavily locked doors. The search for security is fuelled by a media panic about declining moral standards and rising crime. The changing patterns in traditional structures of work and leisure present new challenges for art workers as much as they do for community activists and social policy makers, in re-establishing the need for social values and a sense of purpose.

Arts and Communities, Community Development Foundation, 1992

In a recent article on communitarianism and anti-liberalism, Sean Sayers states, "We are social beings. Our needs and desires, our ability to reason and choose, our very being and identity as moral selves, are formed only in and through our relations and roles...." Assessing the trend towards the new right, left-liberal concoction of 'communitarianism' imported from the States, he suggests we, "need to create new forms of common life which accept individual autonomy and differences of values as real features of the modern world, and which seek ways to satisfy current aspirations for identity and community on that basis."

'The Value of Community', *Radical Philisophy,* issue 69, January/February, 1995

There is a desire for community and social harmony which is neither nostalgia for a mythical past, nor which validates the conservative 'fortress mentality' of extended privilege. Recent legislation in the UK, such as the Criminal Justice Act with its

curtailment of fundamental civil rights, however means the public articulation of this desire is fraught with problems and dangers.

The job of artists in any 'community' setting is complicated by misconceptions filtering down from high art, and shared by some community organisations themselves, that art can cure social ills and that people benefit from being in close proximity to an artist. This creates false hopes which may benefit the artist's CV but takes more from the group the artist works with than what resonates after the project is 'complete'. There is a multitude of predatory groups and political manipulators at work in communities deemed for development, and many will see certain arts activities as part of that. There are successful and less successful elements in any art project – what is required is the criteria by which to assess and discuss these.

A national network

There is not any one central source of information for the areas covered in this book. With the demise of the Arts Development Association in 1991, there ceased to be a national organisation to coordinate activities and information. This body took up some of the role which had previously been undertaken by the Association of Community Artists, then by the Association for Community Arts, then by the Shelton Trust and its magazine *Another Standard* (all now defunct). *Arts and Communities* has set the case for a wider definition of the arts and a central place for the arts in the community in national strategies which necessitates a redefinition of the mainstream to include the voluntary and independent sector. 'Local arts' encompasses youth arts, disability arts, local and community based work, black arts, local hospital and prison arts work, many arts centres, rural development and environmental arts work. In addition there is an abundance of drama groups, dance, new circus, music and publishing of a community base which all have their own networks and regional and national forums. There are many links between all of these which if considered overall paint a very different picture of how art is at work with people than that which we see in the conventional outlets. There are gaps in the book, including Gaelic arts and those of other minority cultures. This is a contribution. Magazines, conferences, books have the role of sustaining information and ideas but at present there is no 'national' voice or way of uniting any number of voices from the different countries or from the regional networks.

There are differences in national characteristic also. Eire is as different to Northern Ireland, as England is to Wales. Scotland is very different again. And all have their own histories of development and

unique examples in action. At the 'Art and Communities' conference in Stirling in 1992, it was generally felt by those present that a national organisation to represent the community arts sector was not a good idea, yet at a subsequent conference in 1994 agreement was reached that there should be an Annual Community Arts Forum. But such forums require continuity in between. Furthermore, founders cannot tell artists how they should be communicating and organising themselves. If networking is left to funders and the official channels condoned by them, then the information to be shared is necessarily the subject of their selection, and inclusion means that you conform to the cultural plan of that year or month. There needs to be a national coordinating group of artists and artsworkers who can collaborate with funding bodies and local government. And only an artists grouping, run on a grass roots basis, well coordinated, and serving and advocating the needs of the particular constituencies, can guarantee effective lobbying.

Organisations like the National Artists Association do not demarcate between visual artforms, including as members those in the voluntary sector as well as those working as fine artists in the gallery system. Quite rightly so as these divisions, based on an hierarchy of value and provision, cannot be upheld in the present crises and need to be broken down. It is hoped this book as a whole advocates that, whilst upholding artistic criteria in single artforms.

The present

In other countries there are models to draw on for the convergence of fine art and community based projects – 'new genre public art' in the USA for example. The relative invisibility of social movements here, and the long-running difficulty of linking arts and social activism, suggests there is a lot of critical work to be done here – or more positively that it has more of a future than a past.

As the concluding chapter in this book suggests, there has to be a blend of the pragmatic with the idealistic. Of course it is much more easy to accept things as they are: that art is about aesthetics; that theory can be separated from experience; that the opinion of an arts bureaucrat is a measure of cultural value. We are constantly told by media commentators that optimism is dead, that the period where it was thought that change could occur is over. This is more the triumphalism of cynicism and the marketplace mentality than the demise of cultural opposition.

See **12 • Community arts development**

Long-time practitioner and theorist of community arts, John Fox of Welfare State suggests that we can "beat inertia with an equivalent tonnage of poems, drawings, manifestos, art objects, processions, songs and airborne graffiti. We think that delight is a significant experience; that every person is constantly 'becoming' and that this process is fed (or starved) by such experience; that starved people make bad citizens." When he proposes an approach to thinking about the arts as "eyes on stalks, not bums on seats", it is for experimentation and innovation to find expression and form which does not conform to the performance indicator approach so lovingly embraced by arts managers, many of whom have colluded with central government policy in willingly implementing its cuts and deep wounds to all social provision, not just the arts. In between the inordinate amount of time artists and organisations have to spend in fundraising and in filling in questionnaires, there have to be some common goals to get folk itching in the first place. The arts may help to make sense of the world, foster critical awareness, give meaning to existence, help to shape self-determined individuals. They are at the heart of learning, and that being a lifetime process they cannot be separated from daily living.

If younger artists start addressing the ways art might be able to situate itself in new social contexts; find ways of debating why and how that is; change the vocabulary to allow that to happen; develop their own working practices, principles, methods and values; find a way to articulate this with shared demands that can effect a shift in national policy; familiarise themselves with their history so as to avoid reinventing the wheel; keep writing that history in a self-assertive and self-critical way that gets distributed; and if they can do this without the mainstream art world harnessing these energies in the service of a narrow critical orthodoxy and already set agenda, then will a groundswell be visible and a new momentum possible? The need at the moment is not just to carry on working between the twin pillars of despair and self-delusion about what is possible and what can be realistically achieved, but also to engage with the philosophical struggle around the 'quality of life' and the eco-politics which eclipse other issues of relative survival in the next few decades.

1 • Looking back over 25 years

Sally Morgan Community arts has constantly suffered from bad press. Marginalised by an art world that found its cultural radicalism deeply threatening, it has suffered from simplistic analysis, and from being judged against the very standards and assumptions it sought to challenge. As a result there is very little useful mainstream documentation of the history, development and ideology of a movement that sought to change the whole cultural agenda of this country, and which has consistently explored the possibility of finding different ways for art to function in society.

In the beginning

Community arts was not born fully formed and armed, like Athene from the head of Zeus, neither was it invented by arts funders to place restrictions on artists. It grew gradually and stridently, through trial and error, through the efforts of artists and communities. This was an empirical movement: trying, testing, rejecting and adapting.

Born out of an unease with extant cultural practices, it began wildly and energetically, gaining impetus from the student sit-ins in universities and art schools in 1968 and hitting the streets with murals, posters, street theatre and spectacular 'happenings' in the late sixties and early seventies. It began as a 'broad church', a loose group of visual artists, theatre makers and musicians who believed that art had gone too far from the people and needed to be reclaimed. In the beginnings we did it on the dole – never expecting that anyone would want to fund us, doing it because it was something that needed to happen. Later we accepted funding, and finally we demanded it.

The people have been making art for centuries, only we don't recognise it because the people who made it were working class, or women, or non-European. It's time to re-evaluate.

In 1971 the Arts Council of Great Britain discovered something had been going on, in 1973 they called it community arts and in 1974

set up a funding panel. A number of groups which had previously been running without state financial aid now received it. By 1977 there were community artists being funded in almost every English arts association area.

Association of Community Artists

Sometime earlier the Association of Community Artists (ACA) had been set up in London by Bruce Birchall, Maggie Pinhorn and Martin

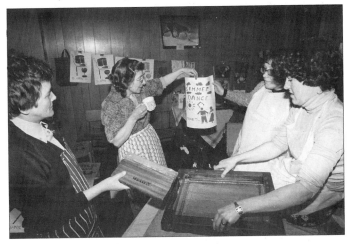

Screenprinting at Cullercoats Community Association organised by **Uncle Ernies**, 1981. *Photo: Stan Gamester.*

Goodrich. It came to my attention early in 1976 when I was Community Arts Worker at Wallsend Arts Centre. Stan Gamester, a member of the Uncle Ernies, also based at the centre, was setting up a regional branch. Soon every community artist in the Northern region was a member with Stan as Secretary and myself as Regional Chair.

In my opinion ACA was the single most important element in the forging of the community arts movement. Through it we discovered each others' work and ideologies. Although later criticised for its reluctance to take a unified ideological stance, it provided a network for practitioners that was never bettered. It functioned as a powerful lobby group/trades union and an invaluable forum for the exchange of ideas and practice. It was through ACA that I became aware of the work of such influential groups as Telford Community Arts, Greenwich Mural Workshop and the Blackie (Great Georges) in Liverpool. I was also party to enormously stimulating and challenging ideological discussions held at national conferences. ACA educated me and

speeded my development as a community artist, it gave voice and form to my political and cultural instincts and gave me the confidence of being part of a vibrant and dynamic national movement.

There were always ideological splits in ACA which I found healthy and invigorating. At one point it was between the 'Urbanists' and the 'Ruralists' then between the 'Hard left' and the 'Soft left'. But in the end various interest groups found it impossible to tolerate each other, probably because we were all in competition for the same money. The urge to concentrate on our differences rather than our similarities produced endless in-fighting and played into the hands of those seeking to tame us.

Ideology

If community arts is anything, it is the manifestation of an ideology. What makes it different from public art, or art in the community, is its long-term cultural and political ambition. Whichever faction one belonged to in the seventies or eighties, there would be a number of points you could agree on, all revolving around the notion of empowerment through participation in the creative process. All community artists shared a dislike of cultural hierarchies, believed in co-authorship of work, and in the creative potential of all sections of society. Some went further and believed that community arts provided a powerful medium for social and political change; that through accessing existing artistic media, acknowledging previously 'low-status' forms such as carnival, women's crafts and non-European arts, and working in the area of social and political issues, community arts could provide the blueprint for a truly participatory and egalitarian democracy.

For many the aim was to produce cultural change, to change society's attitude to art and to artists. Their work was not overtly, or even covertly, political. Pioneers, a group set up in Cardiff in 1981, is an example. In 1994 they professed, "We believe that everyone is born creative, and it is the educational and social circumstances of the individual which make them believe they aren't. We are trying to redress this imbalance. The artists are employed to produce artworks in whatever form and material which is appropriate to the clients. This comes from a belief that as professionals it is our duty to work for and enable others. Normally, artists expect their work to be self-centred and motivated. We encourage them to think of the wider context of the communities in which they are being employed."

From this statement one must deduce that the Pioneers' version of community arts is concerned with communities rather than a particular community, and with bringing opportunities for creative action to as many people as possible. This approach contrasts with static or community-based projects which saw their heyday in the seventies and eighties. Such groups have long-term aims within their chosen neighbourhoods or towns; community artists used to say that they aimed to work themselves out of a job, that eventually the cultural climate of their community would be so changed that their client group would have no further need of them. Sadly, very few of these groups have survived long enough to test the theory.

Cultural democracy

Many of the community-based groups in the eighties would have agreed with Valley & Vale Community Arts in their 1985/86 Annual Report.

"As part of a growing movement within Britain, Valley & Vale believes that in order to achieve true political democracy it is necessary to also achieve cultural democracy. This means working towards culture which is accessible, participatory, decentralised and which reflects the needs of differing communities. Groups have the right to express themselves in their own voice and through their own forms."

The aims of these groups were much more politically overt than, for instance, the Pioneers, and had been since their inception. They worked in particular communities, very often working-class or economically deprived areas, identified strongly with the areas they lived and worked in, and had management structures which closely involved local residents.

Ordsall Community Arts project in Salford, Greater Manchester, was set up in 1978 as a community initiative. A steering committee of residents from the Ordsall Estate, with the aid of The Family Service Unit and Salford City Council, gained five-year funding from the Government's Inner Cities Partnership Fund. This group of residents then advertised for, interviewed, and employed two community artists, Jim Smale and myself.

We were what the Shelton Trust, founded in 1980 to promote knowledge and interest in community arts, called an 'Urban General Project' as opposed to an 'Urban Specialist Project' such as Greenwich Mural Workshop, or Paddington Print Workshop, each of which worked within a closely defined set of media. We worked in whatever medium seemed appropriate. Decisions about policy, direction and

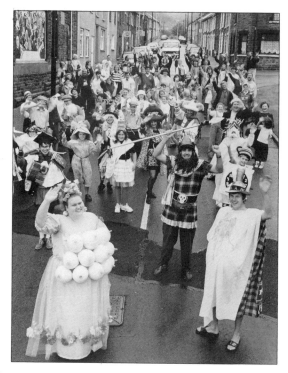

Cast of the Garw Valley Community Play, part of the Valleys Live! Festival, 1992, **Valley & Vale Community Arts**.

kinds of projects were made at monthly meetings which any member of the community could attend. As the 'team', Jim and I would present a monthly report and proposals for future work. These would be discussed by the management group and whoever else attended, and proposals were then voted on. The artists had no voting rights, but this didn't worry us since there existed a great level of mutual trust between us and our employers: the residents of Ordsall Estate.

Ordsall was an area of marked social deprivation, with very high unemployment, numerous one-parent families and a notorious reputation. Our aims included providing a focus for community identity, providing the means to express that identity and to campaign on local and national issues, as well as to provide local groups and individuals with the opportunity of gaining confidence through their involvement in the creative process. Through its Community Arts Project Ordsall was naming and claiming its own culture. It asserted itself through a wide range of projects, through live events involving thousands of people (Ordsall Carnival); hundreds of people (a play done with and by local children tracing the history of Ordsall through the Industrial Revolution to the present day); or tens of people (like the

group of teenagers who painted a mural about themselves as twentieth-century Vikings at the Unemployed Youth Centre). Sometimes the things done were very simple, like videoing the bruises on the body of a teenage girl on her release from police custody and showing the video to local councillors as part of a campaign. Others were more complex – the community magazine or the carnival. Whatever we did was done by, for and through the community which, as a resident, I became part of.

The aims and practices of Ordsall Community Arts were shared by groups across the country. Telford Community Arts was set up in 1974 by Graham Woodruff and Cathy Makerras to "find ways of helping local residents express and communicate their opinions, feelings and experiences of life and to participate fully in the creative and decision-making processes involved."

Influenced by French cultural animateurs Planchon and, more importantly, Jean Hurstel, Telford, like Jubilee, based in Sandwell, began with drama as their main vehicle, although both projects very soon extended their range of media. By the mid-eighties Telford had grown to the point where it had seven full-time workers (many recruited from residents) and an unashamedly left wing stance. By the beginning of the nineties they had ceased to exist – why?

From one standard to another

In 1980 ACA disbanded as a national association. The fight for adequate funding had resulted in bitter power struggles within the association: it was accused of being unrepresentative and centrally controlled. So it was proposed it should cease to be the Association of Community Artists, which had only been open to practising community artists, and become the Association for Community Arts (AFCA) which would be open to anyone. It was also proposed that it should be organised solely on a regional basis. Many of us were passionately opposed to this. The loss of a national network, to me, meant loss of focus for the movement, and the opening up of membership to include representatives of the funding bodies meant that we had no place to organise when our needs did not coincide with their desires.

Before self-destructing, ACA set up the Shelton Trust which, it proposed, would become the new national network. The major problem with this, for me, was that although the Trust would have regional directors, they would have no real constituency to represent, since all regional activity would go on through the now autonomous AFCAs.

Nevertheless, through the early and mid-eighties the Shelton Trust did a valuable job producing publications, information packs, and the bi-monthly magazine *Another Standard*.

In 1982, under the editorship of Ros Rigby, Shelton Trust produced its 'Community Arts Information Pack' in which it described eight varieties of community arts work:

- **Urban 1 General Projects**, eg Jubilee Community Arts
- **Urban 2 Specialist Projects**, eg Paddington Printshop
- **New Towns**, eg Telford Community Arts, Corby Community Arts
- **Rural Areas and Small Towns**, eg High Peaks Community Arts
- **Festivals and Short Term Projects**, eg Hangleton & Knoll Festival, Highrise TV (facilitated by the Social Arts Trust)
- **Young People**, eg Mara Ya Pili (a project working mainly with young Afro-Caribbeans in Leeds), Arts & Action based in Bootle.
- **Work with Special Groups**, eg Freeform, Community Arts Workshop in Manchester, Pentabus in Herefordshire.

A checklist also described what community arts was:

- Community arts is a way of working, not a particular art form.
- Community arts workers use the whole range of media from folk lore to video, from fire shows to puppetry.
- Community arts does not aim to build up audiences for traditional art forms like theatre, although this may be a spin-off.
- Community arts encourages active participation by ordinary people rejecting the trend towards passive consumption in all other areas of life.
- Community arts aims at being closely relevant to the communities in which it happens, enabling people to express local feeling or experience.

Merseyside Arts, with a seven-point list, added the riders that it should occur in "areas of cultural, social, financial need – on a council estate, in an isolated village, in the inner city (for example)", and that it should aim for lasting effect and to create "autonomous and self-managing groups and activity, which can evolve their own direction and priorities."

The drive towards definition in the early eighties came from two directions: firstly projects themselves, and secondly funding bodies. The agendas of these two sectors were, of course, by no means identical. Funders are arms of the state – community artists could be called 'cultural revolutionaries'. Concern with their own definitions of 'standards' meant that in some places funders insisted on conditions like "Aims for a high artistic standard." This is fine as a

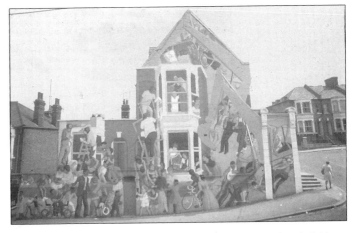

Floyd Road Mural, 1976, painted by **Greenwich Mural Workshop** with 26 local people. GMW started life as what the Shelton Trust described as a 'specialist project'. Challenges from the communities they worked in, diverse interests of artists, and shifts in funding soon broadened their work – into banner making, puppetry, environmental art. The Floyd Road Mural was funded by Greater London Arts and Greenwich Borough. As a result of the project GMW received funding from Gulbenkian and the Arts Council of Great Britain and were then revenue funded by Greater London Arts, and susequently London Arts Board, until 1994. Decline in core funding and changes in funders' priorities have made it more difficult to support a community-based practice. They still receive revenue funding from Greenwich to support community practice. But to work at the levels they would like GMW need to subsidise community arts projects through 'commercial' work – eg public commissions and the like.

long-term goal within shifting and developing definitions of excellence but, when applied in the short-term, is too limiting, taking no account of how long it takes for any group of non-specialists to become confident and proficient, and no account of practices which change, extend and challenge existing notions of quality.

It was also in funders' interest to insist that "(Community arts) can be organised on a long-term, medium-term or short-term basis". This is in stark contrast to the early philosophy that community arts necessarily involved a long-term commitment to one particular community, and legitimised the growing preference for funding on a short-term basis.

Questions of funding, then, had a great bearing on the direction of community arts, and this is perhaps the reason for its apparent pragmatism. Through the seventies there was an expansion of financial support not only by arts bodies but also other government quangos such as Manpower Services, Urban Aid and Inner Cities Partnership. This gave great opportunity for projects to build up a portfolio of substantial funding sources. Unfortunately, this period was brief, since in 1979 a different sort of radicalism was endeavouring to change the world, and it had a far better power base to achieve it from than we had. I speak, of course, of the right-wing radicalism of a Thatcherite Conservative Government. The effect was not immediate, but by the

mid-eighties it was certainly apparent, with many funding sources either drying up or diminishing. During the eighties, community artists found themselves competing for a smaller and smaller pool of money, hence the desire to define more closely and exactly what kind of work would qualify to receive it.

In 1984 the Shelton Trust, under the chairmanship of Owen Kelly and, before him, Bernard Ross, moved away from 'pragmatism' and towards 'principles', and launched its Campaign for Cultural Democracy. Its draft charter put it thus:

• Let us tell the story.... We believe that people have the right to create their own culture. This means taking part in the telling of the story, not having a story told to them.

• This story of ours.... We believe that people have the right to put across their own point of view in their own particular way. This means not being told how to do this by people who don't understand it.

• Now listen to our story.... We believe that people should have the right to reply. This means that people should have equal access to resources to give them an equal voice.

Many community artists, myself included, welcomed this charter with something close to joy. It seemed at last that the movement had a clear aim from which strategies could be deduced. Not only that, but in the draft charter we had something which, in one simple and eloquent statement, encompassed both, the clarity of our aims and the complexity of our modes of action.

In July 1986 The Shelton Trust held a conference in Sheffield, 'Another Standard 1986: Culture and Democracy', at which it presented its new publication, *Cultural Democracy: the Manifesto* which, unfortunately, didn't go down very well with all participants. The problem was that the manifesto moved beyond explicit cultural aims into very specific political aims, and bore only a slight resemblance to the draft charter. In many people's opinion this was a step too far. One discussion group produced a paper, 'Another View', commenting on the manifesto. One point raised was, "Our work is valuable and can be empowering as long as it does not create false hopes either for the people we work with or ourselves.... There is strength in defining and recognising our limits. There is positive value in preparing for change."

Despite this, the conference ended in the Shelton Trust renaming itself Another Standard and in a number of resolutions, two of which had particular significance.

The first stated, "[A working party called] Cultural Democracy and the Labour Movement will develop exchanges of information

Sally Brown, artwork for
Association of Community Arts
conference literature.

concerning activity within the context of struggles against the state,
problems and obstacles of negotiating with the Labour Movement,
collate a list of umbrella organisations and advertise the Campaign for
Cultural Democracy in appropriate publications."

The other informed us that "a working party has been
established to change the structure of Another Standard to meet the
needs of a national campaign group."

Already in debt from the conference, Shelton Trust, with its
new name and constitution, found it was now in breach of its articles
and had to be wound up after a trustee read one of its announcements
in an 'appropriate publication'.

Critiques of community arts tend to dwell on the extremes.
Some have pointed the finger at the 'naïve pragmatists', others have
railed against 'naïve politicos'. In my opinion the strength of the
movement lay in the continual tension between these two wings.
While they co-existed, however uneasily, they produced a functioning
and developing middle-ground. This balance was lost when the
Campaign for Cultural Democracy was hijacked and the Shelton
Trust and Another Standard were dismantled.

From this point the ideological side of the movement all but
disappeared as a cohesive force, and with it went a strong national
voice. The balance of power between funders and practitioners was
broken – funders calling all the shots and practitioners being

25

disorganised on anything but a local level. This means we have reached a point in 1994 when 'community arts' can mean anything RABs or local councils want it to mean. And while there are still those with a clear sense of mission, working towards the principles of cultural democracy, there are many more who have never heard of it and have no sense of the history and heart of the movement.

Preference for short-term funding has made it difficult for anyone to have a long-term plan, and many 'neighbourhood' – based projects have disappeared. Telford, in 1990, chose voluntary disbandment rather than compromise their principles and accept all the restrictions being imposed by their funders.

The present situation

Despite these considerable problems, community arts has produced more change than many would care to admit. Ideas once considered outrageous are now mainstream. Consultation and community participation in public art are now the norm rather than the exception, cultural diversity is recognised as a reality, and the voices of women, the disabled and the gay and black communities are beginning to be acknowledged.

Benedetto Croce contended that art was not "an amusement, a superfluity, a frivolity", but an "essential theoretic function." Neither is that function, in my opinion, the property of just one section of society: it is an essential human function. The American philosopher John Dewey talked of the historic cultural conditions which led to the siphoning off of the creative function into a particular class, and regretted the fact that this gave "sanction to the cultural conditions which prevented the utilisation of the immense potentialities for the attainment of knowledge that were resident in the activities of the arts."

Through creative activity we interact with, gain understanding of, and change the world around us. I, like many community artists, believe everyone has creative potential. I also believe we all have the right to participate meaningfully in the making and defining of our own culture. Art is both process and product, and we have concentrated for too long not only on the product, but on particular kinds of products. Through more general access to 'process' we unleash the potential for products we haven't yet dreamed of.

Good community arts practice is empowering and invigorating, and facilitates true participation in the process of naming, describing and affecting the world around us. The draft charter for cultural democracy still holds good for me; maybe it's time to revive it.

Community arts in Northern Ireland emerged through Father Des Wilson's Ballymurphy Peoples Theatre and the Fellowship Community Theatre at neighbouring Turf Lodge in the 1970s. In the eighties several key organisations emerged including: Neighbourhood Open Workshops, Art and Research Exchange, Belfast Exposed (photography', Belfast Community Circus, Derry Nerve Centre (music, video).

A play I wrote In 1989, 'The Stone Chair' proved to be the first of a series of community plays which included Dock Ward's four productions between 1991 and 1995 and the Shankill Community Theatre's, 'Somme Day Mourning' (1994). At least another four community plays are in progress at this moment in Strabane, Downpatrick, Ballynafeigh and the Ballybeen Housing estate, East Belfast.

The nineties has seen an increase in community arts activities, mainly in Belfast and Derry, and community theatre has been at the forefront of these activities. Probably the most significant development was the setting up of Community Arts Forum (CAF) in 1992. This brought all active groups together and has resulted in a vibrant, muscular, central coordinating organisation. CAF takes an overview of community arts developments and, in particular, acts as a lobbying force for increased community arts funding.

Whatever has been the case in Britain in recent years, in Northern Ireland the community arts movement has developed in leaps and bounds – and shows no signs of stopping now.

2 • Another history

David Harding The democratic urges and idealism of the sixties motivated shifts in art practice relating to 'who is art for?' and 'where should it be made and displayed?' which changed received perceptions about visual art as dramatically as any such change in the twentieth century.

Individualism, self expression and 'art about art' began to be replaced by collaboration, social relevance, process and context. The whole panoply of galleries, dealers and the art market was deemed antithetical to these priorities. Maxims such as "the artist is not a special kind of person but every person is a special kind of artist" (variously ascribed to Ananda Coomaraswamy and Eric Gill); "the context is half the work" (Artist Placement Group); and later "everyone an artist" (Joseph Beuys) give a flavour of the thinking behind these changes. At the same time a rising concern and respect for the arts of non-western and ethnic minority cultures questioned the notion of universally accepted standards in art.

APG and art & context

The shift from studio/gallery axis to 'non-art' sites impacts on form and content, a critical realisation actively pursued by the Artist Placement Group (APG) from its formation, in 1965, by John Latham and Barbara Stevini. APG placed artists in non-art settings, such as businesses and institutions to make art out of that experience. It coined the phrase "the context is half the work" to underscore its philosophical stance. Graham Stevens, one of the formative group of APG artists, which included Barry Flanagan and Stuart Brisley, wrote in 1989, "This might have been called 'contextualism' since it is founded on the recognition that an artwork changes fundamentally in where, who with and how it is made."

Journal of Art and Art Education, no 27, 1992

John Latham, earthwork at Niddrie. Top: *Midriff of the Niddrie Torso*, aerial photograph, at the waist 400m across, 100m high. Below: *Niddrie Heart* in distance with beacon.

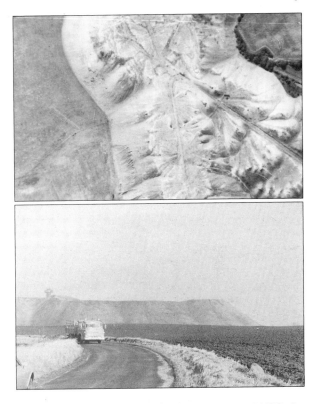

Artists were placed in situations as diverse as the DHSS, the National Bus Company, Ocean Fleets and the Scottish Office. The APG procedural model for placement was exemplary. Artist and institution were brought together for a short initial period with no predictable outcome on either side. This was known as 'The Open Brief'. Out of this came 'The Feasibility Study' which contained the artist's proposal for the remaining period of the placement and, crucially, was the point where both artist and institution could decide not to proceed. This sequence opened the way for the possibility of radical and challenging work which could not have been anticipated beforehand. It was a new role for artists in which process and context became key elements in the subsequent practice. Stevens goes on to claim that APG "grew to make major contributions to the thinking and orientation of art movements of the Sixties and Seventies: Environmental, Light Works, Air Art, Conceptual, Participation, Performance, Process Art, Community Art, Art in Architecture, Artists' Film and Video, Energy, Phenomenalism and Time-Based Arts."

AlthoughAPG continued to place artists well into the seventies the Arts Council of Great Britain (ACGB) and the Gulbenkian Foundation, took up APG's idea of artist placement, ignored the key elements of process and context and turned it into the 'artist in residence'. ACGB proceeded to advertise for, and appoint, a Placement Officer while APG's funding was reduced and finally withdrawn. The much-diminished form of 'artist in residence' became the dominant form of artist placement. This was a major error of judgment by ACGB but, more insidiously, it contained serious elements of suppression, sufficiently documented for John Latham to take the case to the European Court. The case was lost when the court ruled that, since ACGB was protected by Royal Charter, it had no power over its decisions. With the sidelining of APG went the opportunity to develop, over a long period of time, the kind of contextual art practice that it had begun to refine.

See *AND* magazine, no 27, 1992 and *Art Monthly,* September, 1979

Some artist residencies have been very successful but, at the time, they often did no more than provide the artist with a studio in an unusual setting to continue their own work with possibly a chance for the public to see the artist at work. Nothing could be further removed from APG's aims for the artist and the work. Institutions, with their hierarchical and compartmentalised structures, were challenging and potentially fertile settings for artists to make work. They could cut across boundaries and redtape and have access to top management. APG succinctly described the artist in this setting as 'The Incidental Person' and in some cases the conditions were created for putting de Bono's 'lateral thinking' into action.

The Incidental Person, John Walker, Middlesex University, 1995

Community art

While APG placed artists in institutions, businesses and government departments, other artists were committing themselves to sharing their art practice with those most excluded from the world of art. This came to be known as 'community art' and the term has been one of the most contentious issues at the very core of this art practice. It makes the majority of art critics fulminate about condescension and the lowering of standards and it is evident that the whole notion of community art makes them want to throw up. Despite attempts to dispense with it (recent definitions such as 'developmental art' in the UK, or 'new genre public art' in the USA, as used by artists such as Suzanne Lacy) I have never found it problematic and it remains the one with the most common currency. Sir Roy Shaw, arch-enemy of both APG and community art and Secretary General of ACGB, in his

'In Search of Cultural Democracy', *Arts Express*, 1985 Annual Report for 1976/77 defined community art at its simplest as "the activity of artists in various art forms, working in a particular community and involving the participation of members of that community." Shaw nevertheless saw it as a means, eventually, of drawing the general population into an appreciation and enjoyment of the 'great tradition', in other words the democratisation of the received and established culture.

Shaw was taken to task on this issue by Owen Kelly who wrote, "To be in favour of cultural democracy then is not, as Roy Shaw seems to fear, to be opposed to opera, or ballet, or any other of the 'great arts', for they are creative acts as honourable as any other. It is merely to be implacably opposed to the present structure of grant aid and sponsorship which privileges them on an 'a priori' basis against countless other forms of human creativity which are marginalised or disregarded... for our concern is not with producing 'the right art' but rather with producing the right conditions within which communities can have their own creative voices recognised and given sufficient space to flourish."

Developments in Scotland

The Scottish experience has been quite different to that of the rest of the UK and it may be worth speculating why.

Craigmillar Festival Society, founded and run by local people since 1964, is still regarded as a model for the use of the arts in cultural and social action in this country and abroad. The Easterhouse Festival Society modelled itself on similar lines and it, in turn, led to the Cranhill Arts Project. Four of the five Scottish new towns employed artists full-time and long-term to work on public art projects as well as participatory art projects with local people. This practice was adopted by other towns in the UK and abroad. A pattern emerged of artists committing themselves to a long-term involvement with specific local communities.

Could the roots of all of this be found in Scotland's politically active and radical traditions? Active local community politics; a strong sense of identity in long-standing communities; highly skilled in engineering, shipbuilding and craft skills; limited mobility within the country; a certain 'go-it-alone' and 'gung-ho' attitude. This is speculation, but sufficient numbers of professional observers and fellow artists have attested to the distinctive, innovative and long-term

The Gentle Giant, a sculpture of Gulliver, was conceived by **Jimmy Boyle** while still a prisoner in Barlinnie Prison in Glasgow. The construction was undertaken by a team of local people under the direction of the artist Ken Wolverton and local carpenter John Locke. *Photo: Helen Crummy.*

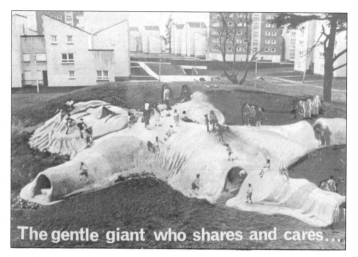

The gentle giant who shares and cares...

nature of contextual and community arts developments in a small country of five million people.

On the Craigmillar council estate in Edinburgh, an arts festival was set up by two tenants, Helen Crummy and Mary Bowie. The founders wanted the arts to play a major role in the life of the estate and, since Edinburgh's world famous international festival rarely, if ever, touched them, they decided to have their own. This was 'cultural democracy' in action and it is worth describing it in some detail.

Craigmillar is an inter-wars housing estate which, even in 1934, was being described as 'ugly factory blocks'. It quickly became a disaster lacking social, educational and employment opportunities and breeding poverty and notoriety. With 25,000 inhabitants in the sixties, it was one of Edinburgh's 'running sores' and in 1968 led the rest of the city in attempted suicides, juvenile delinquency, children in care, overcrowding and tuberculosis.

The focus for the Festival Society was an annual arts festival centring on a piece of political theatre conceived, written and performed by local people in collaboration with professionals. The Festival Society used the arts to become a political force exerting some control over planning, building, social and cultural development. In 1975 it won £750,000 from the EC to strengthen and broaden its activities. At its high point it was responsible for organising and running fifty seven social and cultural neighbourhood projects. Over the years the Festival Society created many opportunities for the arts to flourish employing its own artists, founding an arts centre and setting up community art teams made up of local people directed by professionals.

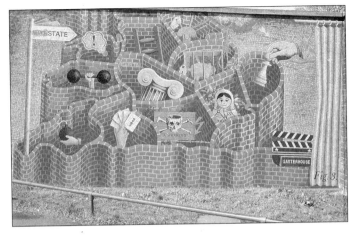

Easterhouse Mosaic, 1983, detail. "Craigmillar served as a model for Easterhouse in Glasgow to set up its own Festival Society. For one project it commissioned six artists to work with local people to design and execute a 200' long wall mosaic. It quickly became so well known that, on a visit to Chicago in 1984, I was asked by some artists if I had seen the Easterhouse Mosaic and did I have slides of it? Easterhouse to many people in Scotland meant crime, vandalism and poverty while in Chicago they had only heard of its art." David Harding. Photo: David Harding.

In 1978 it produced a major report, *The Gentle Giant*, with 400 recommendations on how to improve life on the estate.

With a certain cocky, native flair the Community Art Team, under the direction of Rosie Gibson, invited a New York artist, Pedro Silva, to work in Craigmillar. Well known for his famous Gaudiesque benches around General Grant's Tomb on the Upper Westside of Manhattan, he was commissioned to design and build with local people a mosaic sculpture 60' long and 20' high. The work was strategically placed on the line of a proposed road development opposed by the people of the area. Professional artists, in all art forms, were employed to work alongside local people but, crucially, on terms laid down by the Festival Society. This reversal of the normal practice, in which the community itself invites the artist of its choice, is all the more significant since it pre-dates the surge of professional artists into housing estates and neighbourhoods to direct community art from the top. It also pre-dates Augusta Boal's famous instruction "never to go into a community until that community has articulated its need for you."

The artist in urban design

My own concern for the importance of the context in art-making developed from working in Nigeria between 1963-67. In teaching and organising mural painting and modelled mud reliefs I resisted the

Children cementing tiles to a wall in Glenrothes, 1973. *Photo: David Harding.*

temptation to introduce European influences but insisted that images and forms be drawn from local experience and tradition. This may seem an obvious position to take now but at that time sculpture students at the university were being taught to make Marino Marini look-alikes. On my return to Scotland in 1967 I wrote to towns suggesting they might employ me as an artist. Serendipity played a part and in September 1968 I became an employee of Glenrothes in Fife. I joined the planning section of the Department of Architecture and Planning, set up studio in the Direct Labour yards among joiners, bricklayers and joined UCATT, the union for building workers.

My intentions were to try to de-mystify the artist and to emphasise the notion of the artist as artisan and as part of the workforce building the town. My job description was "to contribute as an artist to the development of the external environment of the town." I contributed to planning decisions and joined the design teams preparing ideas for housing, commercial, industrial, landscape and engineering developments, integrating art works at all levels. Though it was not part of the brief, I added to these tasks the concept of the artist as enabler and animateur so that local people could also

contribute to the development of the town. The term 'town artist' was later coined by Paul Millichip to describe my job in Glenrothes.

The early new towns were built on green field sites and the few buildings existing within the designated area were usually demolished in the name of progress, destroying physical links with the past. Furthermore, as people were moved to these towns from the cities, extended family structures were broken up and social and cultural dislocation ensued. Citizens of new towns needed ways to assert their identity on their town. I went into primary schools and got every child in a class to make a ceramic relief tile signed on the front. In some small way each child was making a permanent visual contribution to their own place. Groups of secondary school pupils designed and painted exterior murals and in one instance a class, described as 'unteachable', began to organise their own murals in the school. I received invitations to speak to groups in the town which I readily accepted as a way of promoting the role art could play in the built environment. Out of these discussions came projects in which adults participated in mural painting and other collaborative work.

Being a member of the planning department meant I could contribute at the inception of developments and a clause was inserted in all planning briefs going to the design teams which stated "the artist is to be consulted at every stage of development." An important precedent had been established. When asked to come up with a colour scheme for the repainting of the front doors of council houses (whole streets were usually painted in one or two colours), I decided tenants should have the opportunity to choose their own colour – an action without precedent. I visited every house armed with a colour chart. After initial disbelief, lively discussions ensued and choices were made of favourite colours or how a colour related to curtains and hallways. In my studio I worked on the drawings of the street elevations indicating the colours of each front door and presented it as my colour scheme to the architect in charge of the project. Any indication that these colours had been chosen by the tenants would have meant cancellation. The doors were duly painted.

Funding and development

In 1974 APG set up a meeting in Glenrothes for the General Managers of the Scottish new towns to promote the idea of artist placements. Although no specific APG placements resulted from this meeting, it helped to reinforce, in Scotland, the concept of a role for

Textile printing in Cranhill Arts Studio, 1989. "The Gathering, a national conference on community arts, hosted in 1979 by Easterhouse Festival Society, attracted an astonishing 400 people. I came away from it with a strong sense that active people were going to continue to demand the arts be integral to their lives. Evidence was not hard to find. In Cranhill, Easterhouse, the Community Council approached the housing officer to set up an arts facility which began in 1981. From the ground floor of a block of flats, Cranhill Arts Project, produced films, photography projects, posters, banners, exhibitions, becoming one of the most successful community art ventures in Scotland. Recently it held a major participatory photographic show in Glasgow's Tramway and opened its own city centre gallery. Some reasons for its success are: the Community Council articulated a need; Lindsay Gordon, SAC Visual Arts Officer, gave solid financial and personal support over ten years; regional and district councils gave support; finally an artist of vision and energy, Alastair MacCallum, was appointed as director. The problems of replicating model projects are well known as the chemistry for success is often fugitive, but it's been said every town should have a Cranhill Arts Project." *David Harding.*

artists outside normal institutions. Meanwhile APG was in the process of negotiating with the Scottish Office to locate a placement at the centre of Scottish government. Due in no small way to the open-mindedness and support of Derek Lyddon and Jim Ford, two of the most senior civil servants at the Scottish Office, John Latham spent six months there as the 'incidental person' carrying out one of the most productive of APG placements, works from which continue to evolve today.

Broader based forms of community art were beginning to evolve in other parts of Scotland particularly with Edinburgh's Children's Theatre Workshop. Under the directorship of Reg Bolton and then Neil Cameron, it ran community art projects throughout the city and beyond. It engaged Ken Wolverton to carry out collaborative art projects with local communities which included murals, sculptures and performance, and in 1977 'storming a citadel of the Edinburgh fine art establishment' by taking over the Fruitmarket Gallery (see *Organised Accident is Art* following this chapter).

Mural painting on exterior walls was, of course, one of the most common ways of involving community groups, not only in an art activity, but also as a vehicle for social comment and criticism. On the other hand some artists painted murals without local participation. Some of the murals contained little in the way of contextual elements and others were only meant to brighten up areas of dereliction. When there was genuine participation by the local community in the development of concepts, in the execution of the

See *Floyd Road Mural*, 1 • **Looking back over 25 years**

painting and high aesthetic aims were maintained by the artists, murals were one of the most effective community art practices. Regrettably too many were executed with low aspiration and skill ending up with the ubiquitous Disney image and letting everyone 'have-a-go'; neither good art nor good community action. Notable exceptions to this in the UK have included the murals of Carol Kenna and Stephen Lobb (of Greenwich Mural Workshop), Brian Barnes and some of the many murals in Northern Ireland.

In 1975 the Scottish Arts Council, in conjunction with Tom McGrath at the Third Eye Centre, commissioned four large gable end murals in Glasgow. Only in one of these did the artist, Ian McColl, encourage participation. One of the murals, painted by John Byrne in Partick, attracted graffiti which initially exasperated the artist. Byrne painted it out only to return to find a new inscription which read "The artists work is all in vain, Tiny Partick strike again." A number of the buildings were due to be demolished which indicated a lack of commitment to the murals on the part of the organisers. Nevertheless it stimulated other artists to paint large gable end mural paintings in Glasgow which eventually became linked to the city's environmental improvement programmes. This led to a group of artists setting up an organisation entitled 'Art in Context'. Similar developments took place in Dundee and, to a much lesser extent, in Edinburgh.

Artists began to find positions within major institutions and to construct roles that allowed them to operate in social settings. In 1978, Hugh Graham, one of several postgraduate art students who worked with me in Glenrothes, was employed as an 'out-reach artist' by Strathclyde Regional Council's Education Department. Using a range of art activities from performance to mosaics, he committed himself to ten years work with local people in the housing estates of Priesthill and Nitshill, developing an exemplary practice. In 1980 Liz Kemp was appointed Assistant Curator at the city museum in Dundee. She immediately used her position to set up a group of artists as an Environmental Art Team to integrate art as part of the environmental improvements in the Blackness area of the city. Backed by the Scottish Development Agency, which had begun to play an important role in the employment of artists in Scotland, and Dundee District Council, four full-time and six part-time artists were employed on the team. Community liaison and participation were key elements of the work. The success of this project quickly led to the setting up of a city-wide public art programme, the structure and organisation of which, has become a model for other cities.

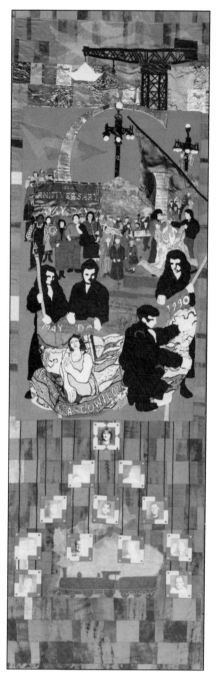

February Banner – Tree of Life, from *'Keeping Glasgow in Stitches'*, 1990. Clare Higney, with extensive practice and administration of community arts in England and a member of the Combined Arts Panel of ACGB, returned to Scotland in 1985 to set up a community art activity based on sewing. She founded Needleworks which produced the much acclaimed banners *Keeping Glasgow In Stitches* made by the imagination and skill of hundreds of participants. In her submission to the Charter for the Arts in Scotland, she makes a cogent examination of how community arts in Scotland "developed by default and not design" as opposed to England where clear policies and structures were set up. "In Scotland separate and separated practice has led to an uneven development of geography, impact, experience and provision." This, she argues, has been a strength and a weakness. Left to its own devices, Scotland has produced some of the most acknowledged and respected community art practice in the UK. It began by communities demanding it as part of community development strategies, by artists committing themselves to it and by local authorities resourcing it. Higney stated though that Scottish Arts Council responded to these initiatives "on an individual basis and has never treated community art as a networked or franchisable practice with collective principles, needs and opportunities it could service and develop." *Photo: Glasgow Museum and Art Gallereies.*

The question began to be voiced, where was all this art activity going and what did the future hold? In 1977 artists began to lobby the Scottish Arts Council (SAC) for some formal recognition of their practice and some directed and specific financial support for its development. SAC's response was lukewarm and it must be some form of indictment that the situation remains the same today.

In 1978 SAC commissioned a report from Hugh Graham and Liz Kemp, which in retrospect looks very like evasive action. A submission from the report's steering group that a resource service be set up to develop community arts in Scotland was turned down and SAC continued to fund occasional projects.

In the *Charter for the Arts in Scotland* 1993 SAC states, "they [community artists] argued strongly that real artistic excellence and innovation can be achieved." And later, "organisationally there is a notable lack of co-ordination in the Scottish community arts scene.... SAC funds community arts quite extensively but in a piecemeal manner. But it seems that there could be a place... for a forum or working group which could bring together all the strands of involvement in this complex form of art activity, identify and recognise outstandingly good practice, work to raise the profile of community arts generally and increase awareness of its contribution to the cultural scene."

Community art has survived in Scotland despite the problems and lack of formal recognition. It has thrown up exemplary practice and occasionally singular strategies such as *Senses Alive,* Drumchapel's arts manifesto. Questions still have to be asked about where it is going and how it can be better supported and developed. Evidence from the USA (including *Art in the Public Interest* by Arlene Raven, UMI Research Press, 1989) suggests that more and more artists there have adopted socially-based, collaborative art practices – amongst them Suzanne Lacy, John Malpede and Mierle Laderman Ukeles – which are given serious attention by writers and critics such as Lucy Lippard, Moira Roth and Grant Kester, who are able to evaluate process, collaboration and context. There is an urgent need for this new breed of art critic in this country as examples of good practice often go unrecorded. There is a woeful tendency to ignore the value of good documentation and publication – gallery and museum exhibitions always have catalogues. Funders could play an important role by insisting on and financing good documentation and publication (for example SAC could set up the forum recommended in the *Charter for the Arts*). We would then begin to witness developments of the radical art practices, involving greater numbers and broader swathes of the population, that community art has long promised and has occasionally delivered.

Filming the making of *Portrait Wall*, part of *Organised Accident is Art* at the Fruitmarket Gallery, Edinburgh, 1977.

The idea and the title for *Organised Accident is Art* came out of working as a 'community artist' in one of the poorest ghettoe's in western Europe. It was there I discovered creativity can deal with chaos. I found a public artist has to work within a tribal format which usually is open, raw and vulnerable. The artist must acquire sensitivity to community energy which can be rebellious, indifferent and traditional. At the same time to survive in such a social battlefield a public artist has to develop skills in organising through gentle but persistent persuasion. The artist then becomes a catalyst for creative change, and is capable of taking something that is unpredictable and crude into something that has continuity and beauty.

The something I refer to may be a public artwork, but it is also the process of creation. I discovered that something can be crazy unsegmented blots of cosmic grit, but if one hangs in there and helps project people's souls by visualising their inner images, there will be art, and it will be fantastic and unique. It will be tribal and fractal.

I wanted to see artists, who were doing work and experiencing it the way I was, come together. I envisioned a big party that was like a 'community arts' jam session.

I spent nearly a year going around Britain talking people into joining in the idea. I had to beg, buy, lie, cheat and steal. Conniving and contriving I managed to bring sixty community artists, animateurs, arts activists and cultural workers to the Fruitmarket Gallery in Edinburgh in 1977, where we worked, played and did a full-tilt arts boogie for ten days (three for preparation and seven open to the public). We created together non-stop each day nearly every form and medium for contemporary art. In the evenings we held seminars where each genre discussed their medium and technique. There was a day-long conference at the end where the art bureaucrat mafia got to act like they did something too.

There were more visitors in seven days than any other show in the gallery's history at the time. The critiques and art reviews were merciless. One of them described us as, "Punk Art Gits!" We knew the established art world felt threatened but we didn't give a damn. We were all young, in love, and on fire.

The only 'art event' I have ever seen since, that came close to this enthusiasm and wacky beautiful craziness was Jean Tinguely's retrospective at the Tate Gallery. He was the man who created art to blow up.

Do I still believe in *Organised Accident is Art*? Well, in principle, yes absolutely. But in energy, my legs are getting tired. You have to act on your feet as an artist out in the streets, and it takes one hell of a lot of energy. To tell the truth, there are not a lot of 'perks' in the biz, either through recognition, money, or even decent sites. I am afraid to say the established, élite art world is still acting like anyone who doesn't play their game must be amateur and definitely not 'commercially viable'. Yep, you'll never get rich in community art development, but as Joe Stephenson, a Jamaican muralist and colleague said to me awhile back, "Ah but mon, you are rich in the soul!" True enough, but it is time for the young to take their talent to the streets, and give art back to the people. There can never be too much art, so celebrate art – and organise an accident!

3 • Gallery education

Felicity Allen with
Sue Clive

Gallery education has emerged from many sources. Its practice reflects that breadth. It works with formal and informal education; with defined groups and with individuals who just turn up; with a range of representatives from statutory organisations, from Ofsted (Office for Standards in Education), Social Services or Her Majesty's Prisons. The individuals who direct and undertake the work draw on their experience in, for instance, arts policy, arts administration, curation, cultural studies, teaching, art practice (whether studio- or community-based, or a mixture of the two), history or art history.

It is a new profession, evolving definitions of itself while accommodating or challenging those that other professions wish it to adopt. Associating itself with current ideas about access, it aims to work with a full range of existing and potential audiences in interpreting art. Working from within, it draws the gallery's attention to the experience and knowledge of the visitor. It builds on the visitor's own knowledge to enable them to engage with, and gain understanding and possibly enjoyment of, particular works of art. While respecting the practice of art and the individual work of art, it encourages a critical response from the viewer. It gives value to critical responses that may have little connection with the disciplines of art practice or academic art histories. It allows people to enjoy, regardless of whether they can draw or have degrees, and make informed interpretations of particular works of art, exhibitions and displays. The interpretive work is carried out in a variety of ways: for instance, by listening, discussing, making or doing. Gallery education aims to work with all art, especially that which is contemporary and challenging.

The recent establishment of the National Association for Gallery Education (NAGE) underscores the development of gallery education as a profession while also highlighting the newness of the status it is espousing. NAGE's declared mission is to assist its members and others to bring to a wide public a critical engagement with, and

enjoyment of, the historic and contemporary visual arts. NAGE's aims, which elucidate crucial issues in gallery education, are to:

- raise the status of gallery education in the visual arts sector
- support and extend the practice and professional development of gallery educationalists
- promote issues of equal opportunity and representation within the profession and amongst audiences
- raise the status and influence of gallery education with relevant professions outside the visual arts sector.

NAGE is expanding rapidly, reflecting the steady development of gallery education. Initially NAGE was largely composed of education officers employed by galleries or curators and exhibitions officers committed to gallery education. Recently it has attracted artists working in galleries and community arts groups working with schools and galleries.

Gallery education is distinct from museum education which is staffed mainly by teachers and tends to focus on the objects on display, approaching them from a range of academic disciplines but emphasising history. Gallery education concerns itself with art and its contexts – 'visual literacy' – and sometimes cultural studies. It is likely to open debate on the meanings behind an exhibition, as well as individual works of art. Historically museums, including permanent art collections, are often better placed to work with education, since many of them were originally set up in the nineteenth century to educate a broad public. However, as David Anderson, Director of Education at the V&A has pointed out, in this century some museums had become so disassociated with education that school groups were positively discouraged from visiting, and institutions such as the V&A had essentially become academic research units with collections. Hence the furore surrounding Elizabeth Esteve-Coll's restructuring at the V&A which more than doubled staff in the education department, signalling her commitment to make the collections accessible to a range of audiences.

Artists as interpreters

Artists working in museums, and on regular education programmes, commonly make work by rearranging displays of a permanent collection, effectively making installations of found objects. In *Mining the Museum,* at the Maryland Historical Society, American artist Fred Wilson commented on the portrayal of a dominant white American

culture, its relation to slavery, and the portrayal by omission of a black American culture. He also raised questions about the museum as a culturally specific site representing a culture back to itself, and about notions of display. At the Tate Liverpool, which shows work from the Tate's permanent collection, Maud Sulter, as artist in residence, selected an exhibition of paintings to question what it was they had in common that led to their regular exclusion from displays. By examining exclusion she was addressing ideas about gender, race and artistic quality.

In contrast, artists working in galleries are usually working with temporary exhibitions. They do not have the flexibility or influence to make interpretations through art practice engaging with curatorship. They are often employed by an education officer who is unlikely to have first-hand experience, at the planning stage, of the original works of art. Increasingly, curators take into account audiences other than their peers when programming exhibitions, but this is not reliably the case, and education officers are regularly brought into discussions only after the programme is fixed.

At best the education officer may be planning a programme based on knowledge of the work through slides and catalogue essays. So artists tend to rely on traditions of education through practical work relating to the exhibition, demonstrations and workshops, or through talks and lectures, but not on curatorial intervention. The shift is toward audience rather than original object since it is different audiences that gallery educationalists build a relationship with. Indeed, there are implicit associations between gallery education, audience development and marketing.

Generally museums' art collections tend to be historic, reasonably familiar and reasonably acceptable to visitors. By contrast gallery education commonly addresses issues raised by contemporary art and curatorial practice. A popular identification of art with appreciation, with the uncorrupted pleasure of being offered a fixed idea of beauty, often results in general audience resistance to contemporary art. Curatorship which supports the high modernist view of the supremacy of solo art forms (verbal language should not 'get in the way' of visual language) reinforces the apparent disdain in which non-professional audiences feel they are held. In the past few galleries have made viewers, on the point of alienation, feel welcome by taking seriously comments that their child of four could do better. One might discuss the fact that it is indeed the work of four-year-olds that some adult artists have aspired to. Instead these viewers were dismissed as prejudiced and ill-educated. By offering art unmediated

by knowledge of theoretical and historical context, the gallery itself becomes the context to be resisted. It is usually gallery education that is in the frontline to tackle this resistance, both towards twentieth century art and the gallery.

The drive to found museums and galleries in the nineteenth century usually contained a philanthropic and educational purpose. Some curators even at that time sought to explain the art exhibited to a general audience. As the twentieth century progressed this was seen as outmoded Victorian paternalism, museums and galleries became more concerned with their 'objects', and education became identified almost entirely with schools and colleges, and individual research. Within schools the modernist move away from academic copying towards 'free expression' degenerated into a commonly held educational view that, to understand or be interested in art, you had to have a practical talent. Until recently the emphasis of all art education in school was on practice, with little recognition of the history and theory of art. At its crudest, you were either a natural or you weren't, and art was valued within the school curriculum for the cathartic expressiveness it released in the pupil. As a consequence, generations of former school pupils, feeling well-educated and articulate, could make neither head nor tail of art made by their peers, which aimed to look 'primitive' – ie apparently ill-educated and inarticulate.

Growing awareness of this discrepancy contributed to the galleries' access movement which responded to a variety of populist ideas – that anyone can make art; that selectivity is exclusive and wrong; that aesthetics is merely middle-class taste reinforced by the academy; that art held by or exhibited in galleries reflects and reinforces the experience of the white, male, heterosexual, able-bodied middle classes. These ideas emanated from and were developed by a multitude of movements and groups and were given professional expression through, amongst others, community arts and gallery education.

Arguments between fine art and community arts were apparent by the late seventies although many artists refused to stay within the polarised camps, making work that crossed boundaries just as their working lives crossed boundaries, often working part-time in community art alongside studio practice. By the late 1970s Lorraine Leeson and Peter Dunn, for example, were established as community artists working in Wapping, London but were regularly showing work in

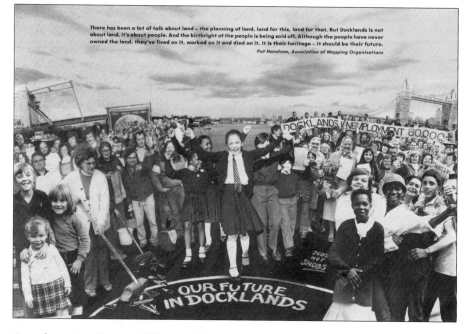

There has been a lot of talk about land – the planning of land, land for this, land for that. But Docklands is not about land, it's about people. And the birthright of the people is being sold off. Although the people have never owned the land, they've lived on it, worked on it and died on it. It is their heritage – it should be their future.

Pat Hanshaw, Association of Wapping Organisations

One of a series of billboards produced by **Docklands Poster Project, Lorraine Leeson** and **Pete Dunn.**

'Ten Years of Gallery Education', Helen Luckett, *Journal of Aesthetic Education,* Vol 19 No 2, 1985

prestigious galleries. Less visibly others working in the 1970s as, for instance, arts administrators and curators were responding in their policy-making and in their exhibition programmes to the demands for representation of other audiences, other artists, and other arbiters.

In response to this debate the Visual Arts Department of the Arts Council of Great Britain split the arguments by maintaining orthodoxy about quality and the avant-garde in exhibition-making while taking responsibility to widen audiences by the new appointment of an Art Education Officer in 1979, with Pat van Pelt as its first holder. Her role was to encourage educational activity in regional galleries through the touring exhibitions programme. A 1983 policy statement on education included reference to adopting, "as one of the prime criteria for assessing clients' work, the extent and quality of efforts made to broaden the social composition of audiences, to develop response and to increase involvement in the arts." Since then the Arts Council Education Department has been established and the Visual Arts Department has maintained its own education officers as well as a touring exhibitions education officer at the South Bank. In 1984 the Arts Council published the *Glory of the Garden* policy document, and funded new gallery education posts in municipal galleries. This reinforced the effects of the development of leisure services

Group from Bangladeshi Youth Association in a workshop alongside a Franz Kline exhibition at the Whitechapel Art Gallery. *Photo: Norinne Betjamann, Community Education Coordinator.*

departments, created by local government reorganisation in 1974. These new, powerful departments had already been putting pressure on galleries to widen their audience appeal.

At the same time exemplary work was taking place in a few galleries, notably the Whitechapel, where former director, Nicholas Serota was working in close collaboration with Jenni Lomax, then education officer, on an exciting programme tapping into the growing commitment amongst artists to work directly with audiences. The Whitechapel Open Shows of the late 1970s and early 1980s celebrated the range of involvement Whitechapel had with its locality, exhibiting amateurs, community artists, children's work, craftspeople, unknown and internationally famous artists together. This policy was soon abandoned and, since the late 1980s, the Whitechapel Open has been often accused of conservatism. Pioneering work in other galleries included Helen Luckett's exhibition touring from Southampton City Gallery, 'Through Children's Eyes', and Cornerhouse, Manchester,

where work made as part of interpreted education programmes was exhibited on several occasions in one of the three galleries.

It was the combination of these developments, and individual initiatives, that enabled gallery education to take off and form as a profession independent of curatorship. The split that occurred in the Arts Council's thinking (maintaining orthodox standards of exhibition while making innovations with audiences) is often exemplified in a split between exhibitions organisers and curators on the one hand, and gallery education officers on the other. There is commonly a hierarchy that privileges the curator over the education officer reflecting the status of exhibition over audience. It is artists, working with gallery educationalists, who continue to cross these boundaries, stepping into the different roles of making and exhibiting as well as organising exhibitions, working with community groups, and developing education programmes. Galleries not only employ exhibiting artists to work on education programmes, but also artists based locally to work on other people's exhibitions.

One of the most innovative independent galleries in London, Camden Arts Centre (director, Jenni Lomax), has a regular group of artists who work together with the education officer to devise programmes aimed at a wide range of audiences. A large proportion of its total budget is spent on education and, like other galleries, only a part of its education work is done with schools. In its award-winning exhibitions programme this gallery has scheduled a number of exhibitions which include some of the artists working in the education programme, reversing the usual hierarchy of artists who exhibit over those working in interpretation.

In the exhibition 'Trophies of Empire', a series of commissions in the maritime cities of Bristol, Liverpool and Hull from August 1992 to January 1993, artists explored the legacies of imperialism against the background of the Columbus Quincentenary and the advent of the single European market. Commissioned work ranged from Keith Piper's video installation to Sunil Gupta's digitised photography. The education programme at Arnolfini, Bristol, included lectures, seminars and a community outreach programme with several inner city schools and A level art students from a school on the outskirts of the city.

The artists planning and leading each project were all of African descent. All teachers and tutors and Arnolfini staff were of European descent. These facts were taken into account in planning the projects. A video project with Cabot Primary School, St Pauls, Bristol and Black Pyramid Video Project from Inkworks Arts Centre, St Pauls involved Zawadi Akinshequn and Wayne Graham working

This section is based on Lindsey Fryer's account published in *Gallery Education: the South West*, NAGE Gallery Education Guides, 1994

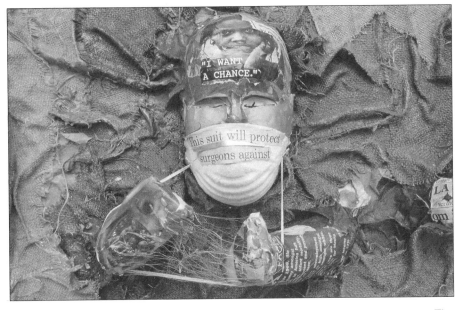

Work from the 'Trophies of Empire' project with Filton College and Sir Bernard Lovell School. This involved eleven European students and one Chinese/European student, aged sixteen to twenty, in workshops led by artist and historian Annia Summers. Through the 'Trophies of Empire' exhibition at the Arnolfini Gallery students explored how racism manifests itself in our culture. Media images of African and European people were also examined and students drew on this to produce a range of practical work, from sculpture to installation.

with 17 African and Asian children aged 6-8. The Columbus discoveries were discussed examining how they affected the world and Bristol in particular. The children responded to the past, present and future by making poems, paintings, sets and characters, and filming their story-telling.

A book project, with St Barnabas Primary School, Montpelier, involved writer Bertel Martin leading workshops with thirty African, Asian, Chinese and European children aged ten and eleven. The children conducted a questionnaire of their parents and grandparents – 'The Travellers in my Family'. They also visited a centre for elderly people who recounted memories, told stories and sang songs. Continuing to visit beyond the project, the children ultimately wrote poems, songs and made art to create a large book about Bristol, other countries and cultures, their families and friends.

Each project was evaluated by the teacher, tutor, artist and the Arnolfini Education Officer in verbal and written form. Arnolfini education has maintained links with all the schools and has worked on several further projects.

We have given this detailed account to raise a number of issues. The exhibition made geographic, historic and cultural links between different cities in England and, by implication, different parts of the world. The education programme drew on these ideas to establish links with communities and community arts organisations. It involved work inside the gallery and outreach. The work on exhibition tended to be outside the traditional disciplines of painting and sculpture and lent itself easily to an education programme which used other disciplines and media and was geared towards story-telling and cultural studies. Typically for gallery education a variety of art forms were explored, despite the fact that the work in the gallery was visual art. Art forms used for interpretation range from dance to music to story-telling, and reinforce gallery education's refusal to limit itself to academic versions of art.

Of prime importance was the establishment of a rapport with groups to encourage them to return. Teachers' professional needs were served by the range of curriculum subjects included as well as by evaluation at the end. Personal contacts were established with teachers to enable Arnolfini Education to continue to work with them and ensure regular new audiences of school children. The programme was expanded further to include lectures and seminars for a wider audience beyond formal education.

Unsurprisingly groups were in primary or further education. Secondary schools find it difficult to work with galleries due to demands of an exam-centred and overloaded curriculum. Primary teachers are acutely aware they need specialist support from gallery educationalists now that local education authority advisory services are being withdrawn. Indeed, considerable attention is given by most gallery educationalists to training teachers, and they regularly work collaboratively with the schools' advisory service as well as independently to provide training for teachers, teachers' previews of exhibitions, and teachers' packs.

Exploring different interpretations of art, gallery education neither negates nor protects the academic. It has no explicit social purpose other than to educate. The questions it raises are about interpretations and art histories and where people are placed in relation to these.

1984 : LOCK MAKERS UNION SUPPORT MINERS AND THE "SILENT NIGHT" STRIKE

Critical research/oral history installations, inspired by, and incorporating material from, archives which I place within site-specific contexts, have become a major format of my work. Over the past ten years I have been engaged in constructing pieces aimed at a broad class audience. This tendency towards researching and making visible working-class cultures through the cultural practice of contemporary art which we are traditionally excluded from, has evolved from my own experience of being a working-class woman.

I have sited work in streets, houses, community centres, factories and on council estates. In the workshop context I have facilitated projects with different age groups, cultural groups, and with people with special needs. The projects focus on the notion of empowerment whereby people look at their own histories through family albums or memorabilia.

From October 1993 to March 1994 I was commissioned by Walsall Museum and Art Gallery to produce an installation for a group exhibition 'In Search of the Black Country'. This mingled objects and memorabilia from the gallery's collection with work by contemporary artists. My interest was fired by an oral history tape in the Walsall Local History Museum of the life story of a woman lock-

maker. I set out to interview ten more lock- and key-making women, mapping out a history from 1916 to the present, redressing the balance in the museum.

The only interesting archival material that included images of women lock-makers was unedited video footage. Viewing the videos, it became clear that the lock-making industry was mostly a male occupation. But there were women in this footage 'in the background'. A video company offered to edit the videos to show those sections of only women working. Within the installation space I arranged seven video monitors. The colour of the screens appeared to float in the black painted space. The multiple images of the women working appeared like a production line, hypnotic and compelling.

Over ten years I have developed a detailed approach towards how I organise and instigate the practice of making work with people in different working-class communities. This has grown out of experience in consultancy, in artists' rights, in knowledge of social history, in lecturing and exhibition organising, as well as the social skills developed in a lifetime of being a working-class person. The strategy of working includes delegation to commissioning organisers and assistants in projects, which are decided at initial planning meetings.

In interviewing people who will feature and be a part of the work, I describe exactly the context for the tapes, so people develop trust and participate willingly. When the tapes are transcribed I send each participant a copy, which they can amend. In *Turning Keys* a further visit followed. After a final edit copies are sent to each participant. The next stage is the opening and the exhibition of the work. Maintaining contact with participants is important, as is care and support.

The lock-makers who took part in the project were Alice Rowley, Eva Ward, Hazel Adams, Kitty Staite, Nellie Whitehouse, Mary Zorek, Edith Nicholls, Ada Howells, Nellie May Jones, Sylvia Cooper, Jane Bayliss, Gerald Walton, Irene Walton, Coln Fraser and Alice Ansell.

4 • Art in education – two stories

Proper skies

Richard Layzell I spent six years at art school in what seemed like an atmosphere increasingly devoid of social relevance. A spell of working in the 'real' world took me from Hackney parks to Hackney schools. I found myself teaching art up to GCSE level in a school where art was used as a way of keeping large groups in one place for as long as possible and with an ex-policeman head of department who regularly finished off the students' paintings for them because he knew how to do it. They would gather round him in small circles marvelling at his skies or people. "Oh, please can you do mine Mr Palmer?" "Give it here then."

This was in 1975. I'd come from a postgraduate course where I'd been immersed in film, video and installation. The gap between my sense of what art was and Mr Palmer's seemed impossible to bridge and when it came to the internal marking for the GCSE my kids lost out because they couldn't do their skies and people 'properly'. They were penalised through having me as a teacher. I resigned. But not without one memorable experiment in bridging this cultural divide.

I spent a risky double lesson with the second year transforming the classroom into an installation. We used cardboard rolls, brown paper, string and paint, turned the chairs and tables on their sides. They enjoyed themselves a little too much. My fragile class control slipped over the edge. It appeared extreme and foolhardy at the time, but when I next worked in a school environment some twelve years later, it was to embark on a similar project. The first in a series.

In the interim I'd been working as a video and performance artist, supporting myself through gallery administration and art school teaching. *Birming-Hands* was a live art commission from the West Midlands Performance Consortium (a group of galleries and promoters in the region). I'd been performing regularly and was increasingly feeling that audiences were coming from one particular section of the population. My proposal was to choose a different target group as an

Children from Dunkirk Primary School taking part in the 'House of Nations' project at Nottingham Castle Museum with **Richard Layzell**, 1991. *Photo: Jerome Ming.*

audience – children. This result was a collaboration between myself, James Watt Primary School in Handsworth, local artists and performers and the Ikon Gallery. We drew together themes of ecology and cultural identity and produced films, video, an installation based on the children's drawings and a large-scale performance which toured the region. The children became collaborators as well as audience. The school, its surroundings and community became a kind of extended studio and resource. The divisions between school subject areas became blurred. The children's home and school personas overlapped.

The installation was painted and assembled at the Ikon Gallery and groups of the children came in to help. It wasn't just the children's first visit to an art gallery but also their teacher's. Educationally, the project was very well received. But my ambitions had been primarily those of an artist not a teacher. This level of support and interest was slightly confusing, especially in relation to my early experiences as a teacher. Artistically, I could assess the strengths and weaknesses of the project. It had crossed several of the boundaries I'd hoped it would. The audience was there, the collaborators were there – if we, as artists, chose to work with young people.

Stephen Taylor Woodrow set up a one-day workshop for secondary school students at Riverside Studios in London. He set them the task of making a living collage. After exploring the figure through collective, gestural drawings, one group pasted over and drew upon a collection of furniture, while another group worked with turf and hands from mannequins. The use of lighting to explore how the installations changed in tone, shadow and atmosphere was a major learning experience.

Crossing borders

Looking more deeply into the educational side led on to writing about *Birming-Hands* at some length, to further projects in schools and to the subsequent publication of *Live Art in Schools* in 1993. This involved actually studying exam syllabuses and the current school curriculum, where there were some surprising discoveries. I had to reappraise my notion of what most schools were teaching. If live art as a category was relatively new and was now bridging the area between performance art, installation art, experimental theatre, dance and music, then it was mirroring developments in schools, not pre-empting them.

There are several GCSE courses which are interdisciplinary, including performing arts, expressive arts and media studies. At primary level 'cross-curricular' projects have been encouraged for several years, although more in some schools than others. Relating this back to my experience in Birmingham began to make sense. Schools are frequently crying out for expertise in both the creative and the conceptual fields. Artists, live artists in particular, tend to be multi-skilled. Their projects inevitably involve equipment and expertise not usually available in the school – eg video editing, sculptural constructions, large-scale acrylic painting, choreography, electronic sound. They also frequently want their work in schools to have a high public profile locally and nationally. Why not? The schools win on both fronts.

With an ever-changing curriculum, and new courses like GNVQs coming on stream, there are many instances where the arts

Passing Through was devised and coordinated by **Fran Cottell** (visual artist/ performer), **Jan Howarth** (artist/ performer/ musician) and **Mary Prestidge** (dancer/gymnast). Among the participants were Grenfell School and Tower Hamlets Youth Arts Project. Two months of workshops focusing on music, movement, shadow play, improvised structures and rowing practice preceded a large scale public event. The audience lined the banks of the Hertford Canal in London's East End and witnessed a cycle of events and sounds passing them on the water and continuing across the lake of Victoria Park.

are being reshaped and some subjects, like drama, actually lost. In other schools, at GCSE level, students are reduced to choosing between art, music and drama, no combinations allowed. At primary level art and music may be under threat, with no funding available for specialist teachers. Here is where an artist in residence can fill gaps and broaden horizons. Not the least of which may be to give teachers fresh ideas and confidence in their own creative abilities. At a recent INSET course for teachers, which I ran at the Whitechapel Gallery, many of those taking part were already trying inter-disciplinary experiments, moving through photography into installation for example. But they needed reassurance, encouragement and information.

Making art

From an artist's perspective what is to be gained? On the most basic level this is a potential source of employment for artists whose artworks usually operate outside the commercial sphere. Then there is the issue of audience. Here is a ready-made community probably unfamiliar with inter-disciplinary art but open-minded and willing to act as collaborators and audience. There's also the satisfaction of broadening their view of what art can be. Additionally, it's a situation where your skills are valued, skills that often seem to be taken for granted or undervalued in the art arena and the world in general. I'm thinking of technical skills (which are often numerous), skills of organisation, communication, collaboration, documentation, a level of ambition beyond the school, a knowledge of contemporary art and performance and an ability to see beyond subject areas, to name a few.

Most important of all though, it's an opportunity to make a public work of art. I feel strongly that the performances and installations I've developed in schools are of no lesser intrinsic value than work I've made for galleries and theatres. The challenges and the creative processes used are the same. In terms of available resources there are more possibilities than one might realise.

- Schools have more control of their budgets since LMS (Local Management of Schools) legislation. My most recent residency, in Tottenham, was initiated and funded largely by the school.
- Schools will have their own network of funding possibilities, often involving the local council.
- Regional arts boards have officers responsible for different art forms, including live art, also artists in education. In general this is seen as a priority area.
- Several of the larger galleries and museums have education officers who will have direct contact with schools and may be looking for interested artists to set up projects.
- The national arts councils may have schemes and can certainly offer advice.

Three years ago I was invited in to Sir Frederick Osborne School in Hertfordshire to work with Year 9 (third-year secondary) students on a cross-artform project. The subject areas involved were art, music and drama. It turned out to be as much of an exercise in bringing the staff together as the subject areas. The project *So What So Welwyn* became impossibly ambitious, intentionally. We obtained the use of the well-equipped local theatre for an afternoon as a venue, involved 100 students, invited the public in as audience and worked it out from beginning to end over six afternoons. Of course it failed on some levels but it showed what could possibly be achieved to sceptical teachers and adolescents.

My view is that there are as many ways of working with schools as it's conceivable to imagine. Once you accept that this is an institution with rules, timetables and crowd control, then it's possible to take stock of what is often quite an open-ended situation where artists are respected. I've found it very beneficial to look beyond the school as much as possible, for a final event, for other expertise, for a wider context. This can give a project more ambition and kudos for the artist and the participants. Of course, it helps if you enjoy being with young people and see them as full of creative potential, but I think a lot of artists do.

League tables

Picking teams

Nina Edge My work as an artist has involved me in various areas of education and training. Although I have no formal training as a teacher or an artist I am both of these things to many people. The providers who have used my teaching services include:

- LEA state schools
- universities, colleges of further, higher and continuing education (arts, and design degree and masters courses, undergraduate and graduate teacher training, in-service and education masters)
- training agencies, council leisure departments, play workers
- community and youth education, gallery and museum services, opera, orchestra and theatre education departments
- supplementary services initiated by communities.

I have also performed the tasks of Regional Coordinator for the Commonwealth Institute and AEMS (Arts Education for a Multi-Cultural Society) collaborating with education providers to expand services already available. My artist inputs in the field cover theoretical and practical sessions, cross-curricular inputs and cross-media collaborations with artists of different disciplines. My coordination role has involved artist training, booking contracts and payments. The service to teachers is advisory, tailoring artists and projects to the National Curriculum, and devising cross-curricular inputs.

The exact services requested by different venues vary in their details and client group but in essence the task is the same for the migrant educator. Specialist skills are developed during my practice as an artist, a cultural overview, a national or international perspective. My ancestors are clearly non-European, hence I am deemed fit to deliver the parts of the curriculum deemed multi-cultural. These inputs are often tacked onto the rest of the education package as an after-thought. The centrality of multi-culturalism differs greatly from region to region, reflecting the creation, evaluation and monitoring of good education policy rather than ethnic composition of local populations. This lack of national consistency is one of the factors that renders the National Curriculum a theoretical rather than a practical reality.

This is the story so far. The education which describes itself as multi-cultural sees a variety of teams who play with enthusiasm and occasional inconsistencies identifying allies and opponents. A range of strategies starts with the simple tourist multi-product (who wears which colour at weddings and funerals) and runs through to sophisticated delivery of authentic outsider art forms, the development

World Ceramics,
batik, 2.3x5m,
1991. Made by
pupils from four
Stafford schools
working with
Nina Edge in
conjuction with
Stafford AEMS
and Stafford City
Gallery

of philosophical and social reasoning, the fusion of ancient outsider forms with contemporary cultural needs. The most effective educators I have met agree that good education is necessarily multi-cultural, since any interpretation of the contemporary world which avoids looking outside Europe will leave pupils with gaps the exact shape and size of black holes.

Own goals – new goals

Education is a large arena, or rather a term describing several arenas, which may overlap, may be held as separate areas, but ultimately share the common goal of information and value transmission. Finding a catch-all definition for art practice is a more challenging task, which results in dynamic debate regarding which art and cultural values may be transmitted as knowledge within the context of education.

Art education is filled with contradictions and assumptions. Improving the service is as much an ambition for some education workers as maintaining the status quo is for others. What might be 'appropriate' or a suitable 'improvement' is constantly disputed, particularly in an era where the political football aspect of the service is allowed to dominate its more altruistic and fundamental purposes. A long period of underinvestment and intervention by central

government has dragged staff morale to new depths creating an environment in which resources and staff are spread very thin between the posts of a state own goal. The fact remains that good education has the capacity to change lives, equip young and old with the skills and vision which will allow the attainment of full potential.

In examining the postition of artists within education services, it is evident that the artist appears as both service user and service provider. To a large extent the qualities of the service provided will only reflect the qualities of the service received resulting in a self-perpetuating, narrow frame of reference which is somewhat resistant to change. It is only possible for educators to reflect their own world view, and extending the world view of teachers, particularly experienced teachers, remains a challenge. Artists working with organisations like AEMS and Creative Dialogue have risen to this challenge and demonstrated remarkable abilities as cross-cultural ambassadors.

A school able to host an artist's visit undoubtedly enriches and expands the education of its pupils and staff. Arguably any worker visiting a school would have an equally positive influence on pupils. I look forward to a time where communal involvement in education might go beyond the managerial inputs of school governors to a point where workers of all kinds add to the activities of all departments' from science to technology. The principle of the visiting artist could be extended to engineers, historians, road builders and refuse workers. Some imaginative schools already bring parents in to talk about their work. An expansion of these activities can only be positive for whole school communities.

Art and teacher training often specialises workers early in their careers. The inputs of varied practitioners into art departments has the potential to broaden that specialist expertise. It also provides pupils with professional role models and helps to contextualise art production and build cultural markets for the future. A more cynical eye cannot help but notice that artists (work in education also represents the somewhat belated efforts of the arts to find purpose) function and meaning for broad audiences.

Moving the goal posts

Following publication of cultural diversity research, and fuelled in part by parental concern, education providers have attempted to devise a service appropriate to multi-cultural Britain. Organisations such as AEMS during the eighties researched and developed curriculum development models for art education. The AEMS projects used artists' visits as the impetus for raising and expanding teacher awareness of cultural practice, while delivering forms and

methodologies new to UK classrooms. Over a period of five years hundreds of artists' inputs were delivered in schools and colleges in seven pilot regions.

As an AEMS artist I have delivered aspects of the science, design, craft design technology, mathematics, english, history, geography and art curricula. The vehicle for these transmissions of knowledge have been large-scale batik works, collectively produced. The batiks themselves are items of some beauty and influence which are only dwarfed by the essential beauty of the confidence and insight which are accompanying outcomes. Each participant also produces their own individual batik which may become part of exam modules or course of study since group work cannot yet serve this purpose. Assessment of students' work in the broadening arena remains a difficult area, examining boards being amongst the last to adjust their vision. Other late developers include degree courses where it remains difficult for black students to pursue certain areas of study, usually on the basis that available staff are unable to evaluate and assess certain images, concepts and objects.

The *National Curriculum for Visual Art* is an interesting document, which at different key stages requires that cross-cultural referencing and critical skills become part of classroom practice. This implies that state education at the highest level has interested itself with the concepts of change, development and expansion. I wonder if this can be evidenced often enough – in graduates, school leavers and all of those who enter the process called education.

Compulsory competitive sport for all

Back to the future then, we have a Heritage Ministry, a Sport and the Arts Foundation and a National Lottery which will pay for culture amongst other good works. This is to become the reality for which people are educated. Who then does this nation belong to, whose heritage can be separated, mediated, replicated, and who will be equipped to make culture and how?

As with any seed, the germ of arts development in schools will develop according to how well it is nurtured. Resourcing of art departments does not at this time reflect their vital role in school as in all life. Teachers may have a great National Curriculum document, but their ability to deliver it, with cross-cultural referencing and more, is dependent on the resources at their disposal. Deep in recession the arts look sadly at school investment in other subject areas, pining for headier days. If school governors can be convinced, if head teachers can be enlightened, if educators can be educated, if mediating contemporary issues can be valued, then art education is set to

deliver one of the most important aspects of education. The creation of something out of nothing – the invention and realisation of ideas.

Everyone in the country is to be schooled, the law of the land says so. Perhaps one of the aspirations of the process could be the removal of fear, and the replacement of this fear, with courage. Art is an area where many might make their courage. No anxiety at the penalty kick.

Ceramic jug with lino printed design, by **Juliette Goddard,** alongside lino ready for printing in Ormond Road Workshops.

Ormond Road is an open access arts and crafts centre operating within Islington's community in London. The facilities include ceramics, printmaking, etching, block printing, silkscreen printing, woodwork, knitting, textiles and sewing. My own work as an 'craftsperson' or 'artist' has moved through stained glass, printmaking and linocut, which I now apply to clay. The process I use involves mixing up an ink, similar to a relief printmaking ink using ceramic oxides as pigments, to roll up the linocuts and print onto wet clay to develop a 3D print.

Ormond Road runs mainly as a 'drop in' facility, which means, unlike many other adult education centres, the day and evening courses allow some flexibility for individuals, whether they be a mother, unemployed or employed, between jobs, etc.

As a tutor in printmaking, I meet people who come into the arts from all other professions, with a current trend amongst unemployed architects who come to develop new ideas in visual communications. This cross-fertilisation of current ideas is common throughout the workshops and has been a great influence within my own thinking and approach. Divisions between 'art' and 'craft' and the bridging of them have come out of interactive situations, and cross-workshop situations which initiate innovative practice among fellow practitioners in the field. In teaching, I try to encourage mainly group work in skills learning and being able to communicate and listen to other ideas, while remaining individual in approach.

5 • The Pioneers

Nick Clements As an organisation we do not operate within the bounds of what is presently accepted as the 'arts world'. We believe in a more interesting view of the world and also a more challenging way of working. We are not interested in pursuing contemporary art' issues, we want to be more open and inclusive in our business. We work collaboratively with others, we are enablers and we are able to bring out potentials within the people we co-operate with. We have three main aims within our business, and the way in which we would appraise or define our jobs. These three goals are really 'mission statements' and we cannot achieve them within everything we do. However as artists we must strive towards ideals. The three aims are very hard to define, but they roughly cover the following:

- humaneness – the ability to respect others, to be loving, to have fun, to be creative, to motivate and to share
- potential for change – not to be dogmatic, to welcome change and innovation, to seek alternative ways and to encourage others
- history and culture – to give a voice to the past and through such knowledge express where we are now, to enable others to fully understand their own potential and to seek ways of achieving it.

We have not always been so clear in our aims. Certainly when we formed in 1981 there was no clear aim or belief we would continue for very long. The reason behind forming was a dissatisfaction with the 'inertia' in the art scene. At that time there were few possibilities for young artists to gain employment. Artists formed an orderly queue behind art college lecturers and waited for shows at prestigious venues. We wanted to change this and realised that as young and unknown artists we had no chance of moving up the ladder, so we pooled our resources and took our art out of the gallery system.

We have always been a highly independent organisation. We have undertaken a few public art commissions for corporations and

Lisa Tann from Pioneers at Cefn Hengoed School, Swansea, working with children on a clay relief mural which was sited in the local leisure centre.

companies, and they have been very disappointing, poorly paid and with maximum interference. It has always paid us to pursue our own contacts and to wait for more attractive opportunities. The policy of self-help arose through the circumstances of our situation – South Wales is not renowned for its support for the visual arts. We are highly motivated and do not like relying on anyone else for money or support.

We produce thirty to forty projects a year in schools, special needs, estates, local authority planning work, work with architects, training programmes, work placements. This complex infrastructure evolved over a long period and reflects the interests and aims of the two directors. They continue to work on the projects, but the majority of their time is spent fund-raising and initiating work.

Most people who call themselves artists work on their own. They pursue their own ideas and motivations through a highly specialised practice. We respect the individual's right to pursue such aims, but we have rejected it as the way for us. We work in pairs or in teams. Within those teams there are obviously dominant characters but decisions as to direction and methods are taken collaboratively. We believe that your potential for creativity is increased by the amount

of contact you have with other people and ideas. Those that operate within closed systems really only ever explore very limited options.

Despite a policy of low profile publicity, we are in the very pleasant situation where the demand for our work far outweighs our potential for producing it. So, we build long-term relationships with individuals and groups who want to work with us. These are mostly schools who want to change the circumstances of their environment by using the visual arts. We work with them to fund-raise. We work with staff, parents and children to evaluate what are the best ways of improving their lot. We share our expertise and knowledge. At the end of this process they may well decide that they actually want to do something completely different – like make a pond and nature area – so they employ other people. We do not want to produce work which is not owned and respected by those who have to live with it; at the same time we do not want to produce work which is a short-term fix ignoring the longer-term implications.

We have worked in a variety of media – film, painting, sculpture, ceramics. We use our creativity to adapt to the needs of the people we are working with, to circumstances of project and to produce an artefact we can all be proud of. The categorisation of artist, craftsperson and artisan holds no interest for us; we use our creativity to enable others to make art which is beautiful and enjoyable.

Allied to this is a belief that product and process are important. Sometimes the process will lead us to an unexpected product, sometimes the product will be clear and easily achieved. There is no dilemma or confusion, we are employed to produce art and people respect how we do this. The product will also include an increased sense of pride, self awareness and confidence for some of our society's least privileged people.

Each generation of artists rediscovers community arts. Some find it does not suit them, some find it becomes a lifetime's work. Unfortunately, many don't really understand its significance or value. They degrade it by claiming 'consultation' and 'workshops' are community art. Public art is not community art. Artists can and have brought about significant social change. It's a pity such work has never been given the respect it deserves. Maybe this is because it's so powerful and of such significance that it frightens and intimidates those undertaking more intellectualised and self indulgent practices. Partly, it's due to the fact that the majority of community artists have just got on with it, and not had the time or inclination to intellectualise it. This book is part of a reclamation of the significance of such work; there is still a great deal to be done by artists, art lecturers and art historians.

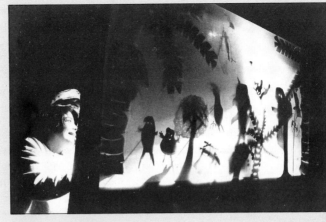

Action Space Mobile, *Shadow Puppets*, taken from the In the Boat Theatre project.

Action Space Mobile is a community arts company that works with all ages and in different situations. It was started in the late sixties by a group of artists fed up with the art world who wanted to take their work to a wider audience. Over the years the work has been influenced by its public – it's been a two-way process. Most projects are now partnerships with people who don't think of themselves primarily as artists – communities, children, special needs groups, people in institutions. We aim to make each project fulfil two aims. Firstly to make an art work that is interesting and extends the creative potential of the participants. Secondly to leave behind a self-sustaining structure of people who will continue to work together.

In the Boat, a group of people with learning difficulties based in Sheffield, has worked with ASM for several years producing performances, an exhibition and a video for schools. ASM and In the Boat use workshops to devise material, make puppets, music and video. In the Boat specialises in shadow puppetry as this a visual means of communication particularly attractive to people who have little speech.

Projects are initiated in different ways. Much of the work is in response to requests from local authorities, community groups or festivals. Some work is company developed. This means funds have to be raised and/or bookings made to cover costs. It's financially more difficult to initiate than to respond. Recent work in Romania with adults in institutions was an ASM initiative built on the experience the company

had in long stay hospitals in the UK. It aimed to get artists
and community into hospitals to change conditions. In the
long term it aims to get people out of hospitals and integrated
within their communities. Arts work earns them respect and
increases their confidence which leads to self-advocacy.
People from outside an institution involving themselves with
residents can put pressure on authorities to improve or
change conditions. Romanian artists were shocked at
conditions but impressed by the creative abilities of the
residents. Arts workers have a voice. They aren't directly
employed by the institutions, they can involve the media.

The work is multi-media – music, dance, puppetry, video
and drama as well as visual arts. The beginning is often a
games structure because it can elicit unselfconscious
participation. The role of the artist is first to stimulate and
value the participants contribution and then to structure
those contributions into a particular medium so that they
can be presented both to and by the participants, and to
their community. Consulting through exploratory
workshops elicits deeper responses than direct questioning.
We believe people reveal aspirations when working
together and enjoying themselves. A shared experience
gives a sound starting point for shared creation.

Technically it's important when working with people
with learning disabilities to break the process down into
each simple operation, and concentrate on, and make the
most of each operation. Each part of a process is interesting
in itself and often requires physical dexterity from people
not used to using their hands. The application of a colour or
the shape and size of a piece of paper need to be explored.
Using scissors or a knife can be a challenge. The final object
can seem like magic.

The work is demanding emotionally and physically and
requires patience to work with people at their own pace. The
rewards are great in actually witnessing change and growth
of confidence. The frustrations are time limitations through
lack of funding or commissions that don't take into account
thinking and development time. Ideally a proportion of the
year should be set aside without projects so that artists can
work alone or together on ideas and share skills. In the
present cultural climate this sort of time can get taken up in
fundraising or report writing.

6 • Experiments with culture

Stefan Szczelkun This is a reflection on two events exploring different relations to local communities where the work was realised. The first was fully involved with the community. The aesthetic specifics of objects produced were given over to local participants within a framework designed and directed by me. In the second people were drawn into the process, but the design and construction of the single large object was entirely directed by me.

In these projects I wanted to maintain my own level and trajectory of discourse. I'm unwilling to accept the label 'community art'. This term isolates work from the arena of serious critiques of aesthetic values and is used too often to describe work which brightens up the surface of a drab environment and distracts attention from the need for a deeper change.

I wanted to contextualise my practice in a situation I felt related to my own working class cultural values and primarily to people who could understand those values. Unfortunately this entails a degree of professional suicide as it can be a cul-de-sac as a career move. But I chose these projects precisely to illuminate that dead end. A 'good' career move would entail the death of my integrity. I still think art is about truth. Not the 'great truth' but being true too yourself.

Emigration Ritual arose from a commission from Hull Time Based Arts to work on the Orchard Park Estate on the outskirts of Hull. The core people on this monster of an estate were displaced from a dockside community as the fishing industry fell apart in the 1960s and '70s. The housing had the lure of inside toilets but it wasn't only the shit that was internalised. The fishermen and their wives and families had produced much wealth for Hull at a cost of many lives. The danger and recurrent tragedies at sea had forged a community with powerful women leaders. All this was destroyed by the arbitrary displacement of families from their dockside 'slums'. The blunt truth, which is rarely stated, is that these people had been cast aside to rot.

Emigration Ritual, **Stefan Szczelkun** with residents of Orchard Park Estate, Hull. *Photo: Allison Hazlerigg.*

Rather than fulfil the role of the artist who 'creates' a diversion to help the authorities survive another summer, I wanted to set up active structure by which people make an image about what had happened to them and to engage in a ritual which could empower by activating this metaphor.

The idea was to make a series of 'house' structures on wheels which would be ceremonially pulled back to the dockland and then exhibited in the Posterngate Gallery in the centre of town. The four houses were made in a week long workshop by small groups of residents. In the end the budget couldn't afford wheels so the houses were built onto pallets and transported by rough-terrain fork-lift trucks.

The house form was chosen to reflect how the loss of a vernacular architecture is central in the destruction of working class culture and life quality. The house is also equated in western modernist mythology with the personality, and the structures made at Orchard Park certainly reflected the diversity of people there. The images produced were a ship, a 'swish' chalet, a revolutionary's hut, and an S&M castle! On the most obvious level these seemed to represent work, home, resistance and oppression. This panoply of symbols was

not arrived at by group discussion but through a lateral process of building and laughter. We started with a short and somewhat embarrassed group discussion of where each person had come from, but from then on the thinking happened with the process of construction.

The houses belonged to the people who made them and returned to the estate as play structures after the exhibition. I would only claim authorship of setting up a situation and in taking responsibility for posing questions and providing a language. This is the main way the event contrasted with *Head of Heads* at Watermans Art Centre in Brentford. *Head of Heads* was part of the Anglo-Polish group Bigos' show 'Aliens'. Here the object was my work, which was later shown in another Bigos exhibition at Cartwright Hall in Bradford.

Bigos is a group of artists of Polish origin who have been exhibiting since 1986, sometimes self-funded and at other times with small public subsidy contributions. The show was made by members who were working with installations and intended to make a show made-to-measure for the site. This resulted in a series of large-scale constructions sited on an island known as Lots Ait. One wall of the gallery is a large picture window through which you can view the island across the tidal Thames. All you could experience in the gallery was a soundtrack of applause mixed by Krystina Borkowska.

I grew up nearby so the local culture was familiar. I wanted my work to relate to the massive estate lying directly behind the arts centre. Watermans' main contact with this estate was the youth who ran through the centre annoying and probably scaring the staff. There was an 'outreach worker' but she seemed to have made little contact beyond the local summer playscheme.

In spite of the proximity of Watermans and the estate, I was starting from scratch. In my experience, making friends within a working class culture is easy. Any surface animosity will usually give way to curiosity, testing, and friendship within a short space of time. I'm a nervous person myself with strangers so the process is not easy. However there is a community centre with a bar, the St George's Club, where I hung out a couple of days. As soon as I got accepted I asked if I could take portraits of the regulars. Taking everyone's photo seemed to be a validating process which became much more intimate than I had foreseen. Some people had never been asked by a stranger if their picture could be taken. The photos were machine printed and pinned up above the bar the next day.

Meanwhile I was working with another set of prints and a photocopier transferring full-size likenesses onto a giant head. I'd chosen to plagiarise an archetype from the past that had always

haunted me – the mysterious Easter Island head which implied a buried giant and a displaced foreigner. I used the same low-key construction technique I had used to make the houses in Hull – ply panels stitched together with string. It was hard sweat to do it all in ten days and I couldn't have done it without voluntary help. Despite some frayed nerves *Head of Heads* was carried to the island at low tide and put in place before the tide turned. It looked dramatic spotlit at night from Watermans' Bar.

The feedback I get from a working class audience is more satisfying than from other audiences. Saying it is 'art' produces confusion and alienation, the historical associations are so unfriendly. So I described the construction by saying, "If a lot of people put their heads together then the product of their thinking can be more powerful than any individual, hence the giant head... etc." This solicited a more positive response and often led to a discussion.

Working class audiences support the art institutions with their taxes and working class artists need to work on their own terms and on their own turf. At the 'Littoral' conference in Salford in 1994 the point was made, by Grant Kester amongst others, that live negotiation was more important than any crude or rigid matching of identities for public work. I agree and yet would argue that there is also too little attention given to the manner in which the undermining of working class culture has long been a focus of class oppression, as I have elaborated in *The Conspiracy of Good Taste*.

I would like to develop these methods of working. However finding venues to tour work of this type is a job in itself. There is little or no support available to extend such projects unless they have a very high sensation or entertainment value.

Another problem in sustaining such work practice is the lack of critical response. The work happens outside the circuit most critics can cover – both physically and because it's away from the cultural high ground where most critics graze. To make matters worse, projects of this sort need the critic over a period of time to appreciate the work in progress. Quality of the work is often more about process than the aesthetic value of any final object or documentation.

A more complex problem is the difficulty that intellectuals across all disciplines have in discussing working class culture in anything but the most stilted and traditional of categories. The idea that 'working class artists' exist at all is seen as a contradiction in terms. Our passage through art school is meant to de-class us. This confusion is mainly caused by the facile stereotype, widely internalised, which lumps everyone who has been to college into a diffuse 'middle class'.

I have argued in *Class Myths and Culture* that all artists are exploited. They rarely get due recompense or recognition for the value they produce, while a small group of people make fortunes wheeling and dealing in the products of dead 'great' artists with nothing going to support living artists. In this respect all artists are exploited as workers. In addition artists who come from blue or white collar homes will carry their values through the educational process to a greater or lesser extent and these are values that, in general, are at variance with those espoused by the art and cultural establishment. Due to the vast and continuing expansion of higher education this means there are a lot of us lower class yobs out there with varying degrees of intellectual certification.

The 20th century shift of common working occupations from hammer-and-sickle-wielding to mouse-manipulating has not been accompanied by an equivalent change in the image of the typical worker. This makes it difficult for the contemporary graduate of mass education to identify with the leaden and loaded associations of words like working class or labour. *Emigration Ritual* and *Head of Heads* were experiments in repositioning my art practice within a working class context.

Action-Speak-Words, an artists twinning initiative between AFTER and Artists Unlimited in Germany, is from a set of six billboard images made on site at the Leinerwebermarkt Festival, Bielefeld, Germany.

Since entering the professional arena in 1986, the notion of the artist/author as the self-determining maker, decider and administrator, has been the core focus of our endeavour and monopolised our energies as practising artists.

In the face of practicalities, ideologies lose some of their resonance. However, ideologies are also the focus of intent and intent is our reason to persist and move forward. At the same time as believing in accessibility and social concern as a focus, we will not beg, or apologise, for our right to be artists whatever our individual social and historical backgrounds. Those two ideals are mutually interposed and give rise to a basic ethos concerning the nature of compromise. We don't believe we have compromised for any audience or social group, whether they have been partners, collaborators, participants or recipients. We have consciously used that ethos to negate self-sacrifice and have therefore moved between polemics and socially interactive welfare – or between 'high art' and 'community art'.

Our collaborators have been internationally respected, avant-garde arts practitioners and local tenants associations, and both at the same time. As artists we are trained and seek to perform to the best of our abilities; we also have intuition and gut responses and are inclined to trust them. It's probable we have also encouraged, and been encouraged by our various partners, to do the same.

Who benefits? Hard to say, there have definitely been substantial numbers of beneficiaries, but, if the artists are not included in that number, then it is difficult to see how long benefits to the audience/community may be sustained. Artists are people, no more and no less, and should be trusted to make judgments about art. This simple ethos is what has worked best for us. The physical reality of art and people called artists is rarely a problem, in terms of accessibility, for our working partners/audience. But the mythologies given to art certainly pose a threat. In 1986 'Order Out of Chaos' experimented with the absence of the term 'art' when presenting work in public. It was a successful gesture, we believe.

Between 1989 and 1992 our presence on Limeside Housing Estate in Oldham (as people with an active interest in that community who also make art) we know was successful. There we were known as artists, and pretty strange ones at that, but we were also known as colleagues, compatriots and eventually guests of the Tenants and Residents Association. Following initial introduction to the estate by Helen Sloan, then outreach officer of Oldham Art Gallery we maintained contact because we had an honest interest in the association and they, we felt, had an honest interest in us as artists. After three years of weekly face to face contact and five paid projects, we drifted apart. Quite simply, the association didn't need us anymore. That counts as a success, though not a very lucrative one. The Tenants Association recognise the same. Various community arts interests though struggled with our 'élitism', were annoyed by us, but also valued our presence in the absence of their own successes. And the various other patronages of the community were simply annoyed and vexed by the whole thing.

We have experience of the 'high art' lobby accusing AFTER of 'low art'; and we have experience of the 'low art' lobby accusing AFTER of 'high art'. It is possible that any problem with the perceived accessibility of the visual arts is more to do with a lack of appreciation of its power, its usefulness and its potential than the relative virtue of its status.

7 • Residencies

Esther Salamon Interviewed for television in 1994 Christian Boltanski said, "Art is a way to speak and a way to ask questions."

I help set up residencies – situations where artists and other people can question their lives and find a voice. Much of my work, and of the organisation I work with (Artists' Agency) is driven by passion. It would in some ways be a contradiction and an impossiblility for me to write about it dispassionately. So what you read here is a personal viewpoint and not our organisation's.

In 1994 Artists' Agency adopted a few paragraphs on its work which, broadly, state its objectives, function and aims.

"The arts educate, inspire and entertain us; they challenge our assumptions, expand our frame of reference and promote mutual understanding."

Mission – "Artists' Agency exists to advocate the validity and value of all the arts, and aims to ensure that the public and private sectors, and wider audiences recognise the importance of, and subsequently support, artists' work in a wide variety of social contexts."

Function – It "pioneers new ways of enabling practising artists to work in social settings often with people and communities who have had little previous experience of or contact with art – in prisons, in hospitals and in the community. The projects, which are primarily artist in residence schemes and national and international exchanges, explore the social role of art. The Agency also gives advice and information to others on artists' placements and residencies."

Aims – "To create an awareness of the importance of the arts in society; to initiate new collaborative ventures between practising artists and people from a wide variety of contexts; to develop opportunities to explore, further develop and broaden people's creative sensibilities."

The Agency's work addresses the view that there is a widespread belief that art is the prerogative of a social élite and far

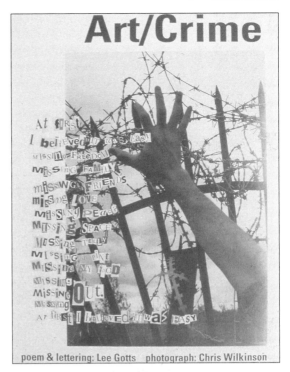

Art/Crime

poem & lettering: Lee Gotts photograph: Chris Wilkinson

Poster poem produced by two 'clients' during writer **Keith Jafate's** residency at South Shields Probation Centre. The residency was organised by Artists' Agency in 1992. *Photo: Keith Pattinson.*

removed from many peoples' lives. For many, it is perceived as a luxury, with artists standing on the margins of society and the process of artistic creation as something intensely private and personal.

The contexts

I want to argue that for the artist to 'speak', 'question' and 'elucidate' they must first be able: to see, to have imagination, to conceptualise and interpret what is seen/felt, and then to have the skill and desire to communicate.

"In looking at the position of art in contemporary life, the theorist, just as much as the artist, should be prepared to engage with a real perception of the social, economic and political conditions with which 'artists' and 'people' are affected."

Artists and People, Su Braden, Routledge and Kegan Paul, 1978

The artist does not operate in a void, nor in a 'context-less' environment and neither does anyone else – we are all 'context-full'. But some would have us believe that source material, the 'stuff' of art, originates from a 'divine' pool which is transmitted directly to the artist's hands, feet and/or voice.

Artists' Agency's work is firmly placed in a social, a political as well as a personal context. Art is a very personal expression of who the artist is and where they are coming from. The artist subjectively identifies issues/subjects they would like to explore and through selection of metaphors, skill and personal style, articulates understandings of themselves.

People operate in social contexts – family, street, pub, school, work, bookies. And where your neighbourhood, bingo hall, park and youth club is situated is largely determined by the size of your wallet. This is inextricably linked to broader issues of economics, power and politics!

"Politics is about the nature and structure of society, its values and the exercise of power." In other words, where you are, economically, socially and even personally is often determined by political beings. They are given authority to govern the state by a minority of the population. Further, they are given the authority to articulate and actualise their aims, objectives and 'programme' through the state's apparatuses – for example, the media.

The State and the Visual Arts, Nicholas Pearson, OU Press, 1982

Generally speaking (and some will say simplistically), it could be argued that for most of the time, and for the majority of the population, others speak on our behalf. They decide what the population needs and wants, who is worth listening to and worth benefiting and who can be ignored, under-represented or even repressed. Furthermore, and rather disturbingly, they are able to identify and control the basic elements needed in the development of the whole person – creatively, intellectually, emotionally, physically, etc.

There are many who do not have the opportunity to develop fully nor do they have the means to express themselves or be heard. Consequently, many people come to feel impotent, feel they have no real say or power over their lives. They are, in effect, without a voice – mute. Broadly speaking, those on the margins are culturally disenfranchised and therefore isolated. They find themselves in this situation due to their socio-economic class, nature of impairment, colour, sexuality, age and/or gender. Consequently, and due in part to their isolation and economic powerlessness, there are ample opportunities to stereotype and misrepresent.

The State and the Visual Arts, Nicholas Pearson, OU Press, 1982

"The involvement of the State in art is wrapped up in values, decisions, attitudes and assumptions concerning people's lives, experiences and social relations." Artists' Agency tries in its small way to redress this imbalance by enabling people (including artists) to find their own 'voice', express their 'words' in their own way and on their own terms, and then 'speak'.

*Journey Through
Utopia,* Marie Louise
Berneri, Freedom
Press, 1982

"Plato [in the Republic] saw very clearly the relation between art and politics. Though he claims to be defending truth and beauty it is clear that he wants to preserve the stability of the State from the subversive influence of free art."

The report *Arts and Communities,* published by the Community Development Foundation in 1992, argued that, "it is not always easy to draw a line between arts in the community and arts provision at large, but a distinguishing mark of arts in the community is the operation of five principles: social concern; the development of individual or group activity; partnership; participation; and consultation."

Another distinguishing mark is that projects in social settings enable the artist to further develop and explore the nature of their own practice in new ways. This fosters 'artistic excellence', and supports and encourages artistic experimentation and innovation. Artists are placed in difficult but challenging situations which provide them with an abundance of source material to challenge accepted thoughts/ misconceptions and offer new understandings.

HIV and AIDS

In the eighties media coverage of HIV and AIDS revealed more about society's prejudices and attitudes to gay men, people of colour, injecting drug users and women than it did about the condition, its symptoms or social context.

Simon Watney, and others, argued that people affected by HIV were grouped, largely by the media's images and text, into broadly two camps: deviants who were receiving deserved retribution for their behaviour (the promiscuous, gay men and drug users); and innocent victims (Romanian children, people needing blood transfusions and so on). AIDS became a way of justifying conventional social mores and a means of reinforcing socially divisive attitudes and inequalities. Issues surrounding representation and, more importantly, the politics of representation were very firmly on the agenda.

I'd like to point out that, similarly to artists, the projects arts administrators decide to pursue also reflect that person's identity, culture, background and passions. As with other people, this motivation might be 'ego-inspired', socially-inspired or even psychologically-inspired. This project was motivated by my concern for people directly affected by AIDS being, effectively, 'gagged' by the media, politicians, insurance companies, mortgage companies, housing departments and others. This gagging was effected through stereotyping people;

Lynne Otter, *Lily.* Produced during Artists' Agency's HIV/AIDS Project, 1992. *Photo: the artist.*

those in power refusing to listen to people directly affected; refusing to fund research into cures; refusing people basic human rights.

In 1988 I brought together representatives from organisations in North East England working with people directly affected by HIV/AIDS. They were what I call 'keyholders', in that they not only know their sector, as they're directly involved with the 'clients', 'patients', members of the community group or whoever, but they were also in the position to refer or inform potential participants of the artist's existence. It must be remembered they can also 'sabotage' the artist's and/or administrator's efforts. So it's vital to involve keyholders at the beginning to ensure the project has everyone's support.

On this project representatives came from the Northern Regional Haemophilia Centre; Plummer Court (a residential drug and alcohol unit); Body Positive North East (a voluntary body providing help and support in the region to those affected); Community Support Centre (the statutory sector's response to support required by those affected in Newcastle); and the Sexually Transmitted Diseases (STD) section of Newcastle General Hospital.

As people aren't usually familiar with the notion of residencies, nor professional artists for that matter, I first explained what the Agency's work aimed to address. Over numerous meetings we also discussed the nature of their work, their clients'/patients' interests and the media's/society's two-dimensional views of HIV/AIDS. We also looked at the potential/feasibility of engaging a practising artist to enable those directly affected (people with HIV and/or AIDS, nurses, counsellors, family members and friends of people living with HIV and/or AIDS, etc) to creatively express their concerns, interests, hopes and fears in their own way and on their own terms; and to facilitate the learning of new skills to 'broaden people's creative sensibilities'. In addition, we wanted the residency to give the artist the time, space and money to produce work of their own which promoted new understandings and interpretations of the issues by creating imagery, metaphors and perspectives which confronted the various aspects surrounding the infection which the media, in particular, were distorting.

We deliberated when attempting to identify an art form – should I fundraise for a fabric artist, painter, photographer, writer, film-maker, etc? We even felt uncomfortable about trying to write a proposal to raise funds. It was decided to elicit the views of potential participants. We distributed a questionnaire defining 'residency', and asking whether they agreed with the notion of the project; their preferred artform; the preferred project-base. Discovering all the respondents felt a residency was a good idea, with equal numbers expressing a preference for both photography and creative writing, while opting for bases in Newcastle and Cleveland County, the group felt able to proceed. But it took me three years to raise the necessary funds required before the nine-month residency and commission could proceed.

Close collaboration and mutual support continued among the group throughout the the project. Representatives from the organisations, in addition to 'arts-based' ones such as Projects UK and the Laing Art Gallery, were involved in shortlisting and interviewing candidates, ensuring, as far as possible, that communication remained clear and open. Photographer Nicholas Lowe and writer Michael McMillan began the residency in late spring 1991.

The monthly meetings which followed were minuted to ensure clarity and avoid misunderstandings even though they often included sixteen or more people each representing different concerns. In addition to the office space, workshop and equipment, artists were given access to trained counsellors not involved directly with the project, as and when they needed.

A full week of events was organised in 1992 which included three exhibitions; public, site-specific and theatre-based performances; the launch of a major publication *Living Proof*; and the siting of one of the images produced by Keith Livingstone and Nicholas Lowe on ten billboards throughout the UK.

A Critical Year, 1985.

Paul Overy said that art enables "the spectator to see with new eyes." I hope the project contributed in some way to 'new eyes' as the old ones certainly weren't seeing the situation clearly. There are many anecdotes with which to make 'rash' assertions on the subsequent effect of the HIV project as it impacted on the artists; the people involved in the workshops; those engaged over the year to undertake short-term, specific pieces of work (designer, editor, actors, technicians and the like); and the originators of the project.

"It's changed my life" – "I never thought I could do it" – "It helped me re-define my role in society as an artist" – "It made me understand that other types of collaborators were possible" – "It stopped me feeling guilty about being an artist"....

Whose imagination?

I doubt whether the points I'm making, or the issues the agency attempts to address, will be seen as profound or unique. When I attempted to get support from an official of the Organisation for Economic Co-operation and Development (OECD) for a project using artists, art, people and technology in an exploration of social class, I was virtually dismissed out of hand and told, "issues of access are very much out of the seventies." He also queried the notion that 'ordinary people' had ideas. He continued by saying he was more concerned to explore planners', architects' and artists' "impoverished imaginations."

Cities are places of exchange which need to involve all citizens in its cultural life and development. If we continue to virtually ignore those increasingly excluded from the means of creative expression then cities will continue to pay the price of 'sustaining' a growing population which is alienated and disenfranchised. Strategies for 'democratising culture' need to be at the top of the agenda, particularly in a world which is increasingly expressing its intolerance, xenophobia and racism through violent means in our towns and cities.

Publicising their work a few years back, Artangel Trust said artists "operate at the cutting edge of social representation – challenging, stimulating and changing traditional views of the world and the way we think." We need to remember that.

Mark Pawson installation in Copyart workshop, November 91. *Photo: J Pawson.*

Community Copyart was set up in 1983 as an open access resource centre for users to create their own printed material from start to finish in a single workspace. The centre workers, a co-operative of artists and designers, were on hand to show users 'how to do it' rather than doing the work for them.

Situated behind Kings Cross station, this unique centre attracted a lively, diverse London-wide user group of community and residents groups, students, artists, musicians, designers and many individuals. A continuous workshops and exhibitions policy reflected the interests of these users and workers. The workshops demonstrated how office technology such as photocopiers and computers can be used as a 'hands on' artist's tool. These practical workshops often toured to arts centres, community groups, campaign groups, galleries, schools, art colleges, and artists' studios. Amongst many issue-based shows were artists' responses to Clause 28 anti-gay/lesbian legislation, black women's perspectives and animal rights issues as well as solo and group exhibitions.

In 1993 equipment available included 5 photocopiers, a colour laser copier, 3 Apple Mac Computers with scanner, printer and IPU link to the colour copier, together with layout and design areas, an image library and an extensive range of papers.

Between 1985 and 1993 Copyart established itself as 'the' premier UK exhibitions platform for photocopier-related artworks. In 1991 Greater London Arts withdrew their grant to Copyart 100% and that was followed by standstill grants from Camden Borough Council then a 50% reduction. The centre was forced to shut in February 1993.

8 • The prison audio project

Nicholas Lowe with contributions from **Alan McLean**

In early 1992 I was approached by Alan McLean to collaborate on a project based in prisons and with offenders in the UK. Alan's initial enquiries to me came in response to the work I had undertaken on the Artists' Agency HIV and AIDS residency which included work with offenders. It was not my experience of prison work that Alan was looking for, he was interested in the approach I had brought to the residency process in Newcastle upon Tyne. My interest in working with Alan had been aroused through his performance works which I first saw in Arnhem in the Netherlands, through which he discussed obsession and male identity. My attention had also more significantly been drawn to his collaborative performance work with Tony Mustoe, who is affected by cerebral palsy.

We had both been collaborating with individuals who had no formal arts training. We had both understood that the changes our collaborators were going through were enhanced with an increase in their self esteem. Also their developing practical understanding of our working processes meant they had begun to show their potential as autonomous visual artists. It was clear from this point that our work was not simply a matter of education but that it had as much to do with approaching our collaborators as equal human beings with valuable skills and experience to offer.

HIV and AIDS residency

My aims at the outset of the HIV and AIDS photography residency were to provide a space where individuals could represent themselves on their own terms, challenging mainstream assumptions and misrepresentations around HIV and AIDS. What has since emerged is the readiness and ability of some of the people I worked with to take up and continue this challenge. One of my principle collaborations

was with Keith Livingstone, a man with considerable professional experience of work in HIV care provision, who no longer works full time through increasing ill health. The collaboration with Keith Livingstone provided him with the chance to explore ways of speaking about his increased self awareness since becoming HIV positive. Together we discussed artwork, working processes and representations in the mainstream.

Collaborative performance

Alan McLean &
Tony Mustoe,
Snoozyland, 1994.
Photo: Brett Dee.

Alan McLean and Tony Mustoe have explored issues of identity through developing a common performance language. Their performances develop through workshops which take the form of verbal and physical discussions, raising issues which on the surface are about notions of ability and disability. On closer examination the product of their carefully negotiated communication emerges as a discussion of masculinity, identity and society.

In one piece, *Snoozyland*, Tony performs a Karaoke with a microphone, while subjecting Alan to structured tasks, which appear like dares or forfeits. In outward appearance the activity and action is like a series of games which mimic childish play; the adventure fantasy games of childhood, dressing up games and ghost impersonations with a sheet, or mimicking the WWF wrestlers' victorious poses. On closer inspection another reality is expressed, the games become metaphors of frustrations and the many crises of identity experienced in daily life. Though based on games they are coded replications of the lived experiences of Tony and Alan.

New work in prisons

Important to Alan and myself, when structuring the Prison Audio Project was that work should impart skills which allow participants to construct a common ground to continue working beyond the short residency experience we were offering. Though not a new aim for artists working in the community, we understood how controversial this approach may appear in prisons and with offenders. Our work is based on understanding that artwork and creativity are a valuable means of raising self awareness and building self esteem. So our work has proved more easily achieved with men in therapy – who are already recognising a need for change.

The Prison Audio Project was conceived as a collaboration between ourselves and offenders and we chose to tackle debates of representation as a central concern. In locating this work in the clear cut, social context of the prison and directly enrolling prisoners in the process of re-representing themselves, the work questions the right which the art world and the media assume when making representations of individuals in so called 'marginalised' groups.

Terms like 'ethnic minority', 'AIDS sufferer', 'disabled', 'homeless' become attached to socially disenfranchised groups as a means of quantifying and containing them. Inclusion of prisoners in the process of producing artwork is also a direct critique of traditional photographic practices common to documentary and photo-reportage – forms which constantly define a subject and object. We disrupt this duality by enabling participants to be both maker and subject. The debates of representation central to photography have become critical to working in performance, video, and audio recording. What is produced is of a high quality. This too is essential to the success of the work, so that what is produced has similar production values to television, radio and gallery-based fine art.

The audio material features male voices detailing aspects of their experience which are not crime-related and heard as stories by anonymous male voices, rather than the voices of convicted criminals. This makes them more accessible to men generally, enabling perhaps unprejudiced discussion about what is said. Through the issues raised on the tape the listener's own behaviour and identity is drawn into question. Issues raised on the tape are selected in one-to-one discussion with prisoners and are selected by asking "what would have a relevance to men in general?" Subject matter includes discussions of friendship, winning, fathers and advertising.

We intend to use the tapes as part of future workshops in prisons, probation centres and youth work settings with men in the UK. This aim is made clear to prisoners at the outset. Interestingly we became aware of an existing tape exchange network between prisoners. Our access to this prisoner network is as yet limited, though it has not been ruled out as a potential distribution possibility.

Artists' initiatives

When we start a project our work is announced as artwork, detailing the collaboration between the two of us. We discuss the social context

From the *Prison Audio Project* by **Alan McLean** and **Nicholas Lowe**, 1994. *Photo: Nicholas Lowe.*

for the artwork stressing our autonomy from the prison institution. Our experience of establishing residencies with offenders demonstrates clearly how as independent artists entering the prison sector we can have a greater effect than for example the resident education

programme. When the prisoners see how our work is contextualised, the level of trust and investment of energy they then bestow makes for more complex collaboration. Participants in workshops know we are not connected with official programmes and often speak more openly as a result.

Collaboration with the host institution is also essential in planning, and during the workshop process. One residency with men on probation involved intense collaboration with probation officers. Three days of meetings ensured the workshops were properly designed but this level of collaboration was only achieved through gaining the confidence of the probation officers.

This raises numerous quuestions around artists' work in social circumstances. How are needs assessed when providing art workshops in an educational or therapeutic context? Can funding criteria respond to those needs? Questions around the status of collaborative arts work and the products of artists' collaborations with untrained individuals need to be raised. The structure and definitions which form the remits in national and regional arts board policies must be drawn into this debate, along with policies for including arts projects in the work of other potential collaborating institutions. Government departments, local authorities, local health care trusts need to structure more formally their relationship to arts councils and regional arts boards. The professionalism of the artist's CV should be drawn into question against the equivalency of the lived experience of the non-trained artist. There is a need for this discussion if artists and others are to collaborate with integrity.

Many residencies produce benefits mainly for the artist and their CV. The longer-term cultural aims of the people a residency can touch may too easily be seen as a by-product rather than the point of a residency.

There is nothing new in these questions. They have been asked by the community arts movement since the sixties. Will community arts remain a practice marginal to fine art? Or will examples like Helen Crummy in Craigmillar, or Paulo Freire from Brazil be constantly rediscovered by successive generations rather than taken up and implemented?

See **2 • Another History** 'Developments in Scotland'

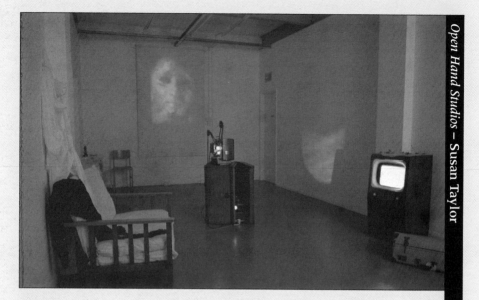

Folake Shoga, installation at Open Space, 1993. *Photo: Marcus Cole.*

In general art education does not include the 'how' of surviving in the world: artists have often not learnt to interact with each other or work together. They face having no resources when they leave college and have no idea what their relationship with the 'public' might be, what their role is or how they might approach prospective projects, clients or employees. The model of artists' studios and artists' groups, however, illustrate certain ways that artists have tried to bridge those gaps and to provide their own enabling structures for interaction between themselves and with the different 'publics' that can be involved or addressed.

Open Hand Studios was set up in 1982 after a year of protracted discussions with Reading Borough Council and, after searching several locations, the ten founder members set up studio space in an old army 'keep'. At this stage there was a flush of success in the air and lots of energy and enthusiasm for how the group might become integrated within the local community. Initially this was open studio days as part of Reading Festival. In 1987 the open studios were accompanied by live avant-garde music which gave rise to the idea of bringing more of such work to Reading to stimulate both artists and public, and provide a forum for

discussions on the role of contemporary art. This more and more included 'alternative', non-mainstream or unconventional art.

A grant from Southern Arts to rebuild the studio partition walls allowed an exhibition space – Open Space – to be incorporated in the studio complex, which was completed with funding from Reading Borough Council.

Part of the studio's role has been to demystify contemporary practice and concerns, to involve people in issues and to share the exciting things that are happening in current avant-garde contemporary art practice. Many of the exhibitions are installations, but also performances, film and video screenings as well as more conventional uses of the wall and floor space for painting, printmaking, photography and sculpture. There has been a tradition of running workshops open to the public by visiting artists and all events/exhibitions are accompanied by artists' talks to involve people and allow artists to test out ideas in a public forum.

Southern Arts presently provides a revenue grant for programming. All building, secretarial, administering, bookkeeping and curatorial work is done with no pay by the artists. Each event or exhibition is instigated, on the whole, by one artist who bears overall responsibility for that event. All events and exhibitions have been of a broad artform base and invited artists have been geographically widely spread.

An 'artist-run' operation is very different from other types. It benefits from the self-motivation and versatility that are learnt during art training and from the 'hands on' knowledge that artists possess about the requirements and needs for creativity. Artists' studios provide for a sharing of skills on the widest possible basis – technical, administrative and contextual. Equipment, tools, books and magazines can be bought communally, shared and remain as a resource. Data and mailing lists are built up and the studio becomes part of a network of activity.

It is important that these are provided for regionally and not only in the main urban centres. At present it is as much a priority as ever that artists' groups keep communication and ideas open and flowing between themselves and their publics.

9 • Public/Media/Arts

Sean Cubitt The argument goes: either you're devoted to the public, social, political agenda at the expense of art, and you make bad art as a result; or you're devoted to art but feel you ought to make some sort of statement, as a result of which no one can understand what you're trying to say. Alternatively, as the example of the photomontage artist John Heartfield seems to say, you have to redefine 'art' so massively to include the public nature of his work that you may as well own up that the master-satirist of Weimar Germany was a graphic designer.

This line of thought is particularly striking in the context of media arts. The words 'media' and 'art' go so poorly together. Besides, the media, especially the moving image media, have an entirely different kind of history, an entirely different place in public perception, a wholly different group of problems. Media people talk about access, accountability, censorship, bias; artists talk about creativity, integrity, aesthetic success. This means the peculiar hybrid of public media arts has two histories. Media arts centres on the creation of a domain of artist's work that stretches from the avant-garde cinemas of Ferdnand Léger, Man Ray and Luis Buñuel to the computer graphics of William Latham, Marc Caro and Karl Sims. Public media traces a more roundabout story from the workers' film vans of the 1930s, to the video diary and other broadcast access slots, encompassing a range of work from community video access workshops to campaigns in defence of public service TV.

An example of what can be achieved, and how that questions the notions both of access and of art, is Peter Watkins' extraordinary 14-hour documentary *The Journey*. Watkins is best remembered in England for his banned dramatisation of the likely effects of nuclear warfare *The War Game*, and for his satirical and mould-breaking account of Culloden, the battle that sealed Scotland's colonial status in the United Kingdom. Pretty much hounded out of broadcasting, he turned his hand in 1981 to making a film which would not simply update *The War Game* but provide an entirely new way of organising

and financing its production. The work was finally completed in 1985, after shoots organised locally in North and South America, Asia, Africa, Europe and the Soviet Union. Watkins' achievement is partly in the film itself and partly in the way its production served as a focus for peace organisations around the world. Extremely rarely seen because of its politics as much as its length (never a problem for TV anyway), the film deserves to be seen as art by at least one definition – it challenges, root and branch, the aesthetics, politics, institutions and processes of the medium in which it works. But it does two other things. It addresses issues of public concern beyond art; and it would have been unthinkable otherwise than as a project made by large numbers of people.

Media debates have hinged on two key terms. The first is representation, both in the sense of how media portray some groups (strikers, the Irish, women) and in terms of how people are placed in the industry to speak out for the groups from which they come (the 'regions', Black Britons, Islam). The second is the notion of dominance, most persuasively seen as the outcome of prolonged, continuous negotiation/struggle over the means and mode of representation in a society riven by political, economic and cultural differences.

But in the light of Watkins' work I think we need, in place of representation and domination, to think about mediation. How the public world, full of a billion conversations everyday, is mediated through institutions, texts and the cultural rituals we have for receiving them. All our communications are mediated, even when the mediating media are as involuntary and natural to us as facial expressions. Genuinely public art, whatever else it does, has to access the way in which public life today is mediated. To paraphrase Walter Benjamin, public art that tells us nothing about mediation tells us nothing.

Farewell the gogglebox

A central plank of the development of lightweight video in the early years was the perception of communication as a right. This remained a focus for agitation through the cable experiments of the late seventies and the beginnings of the workshop movement in the early eighties. The principles of community arts were simple – access to equipment and editorial control for anyone living in the area. This geographical bias towards home life (where so much of the history of radical film in the UK had been workplace-based) arose from two sources – a profound dissatisfaction with the institutions of the arts

and media to provide a living culture for the majority of the country's population, and a conviction that the personal politics of locality were more important than the glittering prizes of national life. *The Directory of Video Tapes* produced in 1979 by the London Community Video Workers Collective gives a flavour of the work undertaken. The headings include health and safety, youth, tenants' campaigns, racism, pensioners and citizens' rights.

Community Media: Community Communication in the UK, Heinz Nigg and Graham Wade, Regenbogen-Verlag, 1980

Video with Young People, Tony Dowmunt, 1987, Inter-Action/Cassell, 1980

The central attractions and disadvantages of video in community arts were summarised by Nigg and Wade thus, "Video is suitable for process work.... Video has the symbolic power of television. Because of the TV set's small size and intimacy, video is the ideal medium for small group discussions.... Disadvantages: Video is expensive compared to photography, with a high risk of breakdown if the equipment is poorly maintained.... There are no standard distribution networks". Tony Dowmunt, writing in the late eighties, is still working with the same conceptual apparatus, "Specifically, any pictures or programmes recorded may simply be the starting-point, the stimulus, for a far more important process – the involvement of people together in planning, analysis and expression." Video practice downgraded the textual aesthetic of modernism. Its goal was mutuality of cultural production, in opposition to the authored discourses of contemporary art. Core to the aesthetic was the notion of enabling, as participants and represented, those generally debarred from arts and media.

Much public media arts, and very probably much public arts in general, is intensely local – one reason for the lack of interest in it from art magazines and career-oriented professionals. Occasionally, events give rise to opportunities to make contacts between big art and local, as happens in Liverpool with the Video Positive biennial of international electronic media arts, which always hosts a major programme of work made by local groups aided by practising artists. Louise Forshaw and Simon Robertshaw, artists with growing international reputations, have acted as animateurs for local groups to produce ambitious installation works in major public sites.

The working process is intriguing. Few Liverpudlians need direction to read the bias of the media. A common first approach to the idea of making video work is to see it as a chance to redress the balance of TV's misrepresentations of the city and its cultures. What makes this more than a project in positive images is the introduction of a further idea – that TV is not the be-all and end-all of video. The dominant forms of broadcasting are, to all intents and purposes, dead ends, forms so familiar they have become ossified in arcane and

An example of a project which became a partnership between gallery, educational institution and artist was *Sight Specific*. A group of A level students from Southport College worked in collaboration with video artist Louise Forshaw. The original idea began with discussions of personal anecdotes. The story selected was about someone playing football when a spike went through their foot because the pitch had been laid on a rubbish tip. As ideas developed the intentions became to represent the 'unseen' and the deliberately 'obscure' ie issues being swept under a metaphorical (grass) carpet. Eight televisions showing video recordings, mainly of grass, were laid on their backs on a carpet of wood chippings. Subliminal imagery and sound also appeared gradually after a full five-minute sequence of grass. The installation was shown at the Video Positive Festival in Liverpool in 1993. *Photo: Sean Halligan.*

immovable bureaucracies. It's in this light that the effort to make installations takes shape. Farewell the restrictions of the goggle-box, and farewell the endless battering at the doors of the BBC for a right of reply in a controlled TV environment. Here the process involves the common production of art, understood as a practice in which it is necessary to invent the form as well as the message. The secret enemies of early public media arts, the institutions of the art world and the media, are pushed into the background in an attempt to invent a new medium, and make communication not self-expression the core of the practice. The experience of artists Forshaw and Robertshaw has been that the most difficult stage of the project is expanding the ambitions of participants, more than unleashing their creative talents. But that is also the point of undertaking the work in the first instance.

Shifting practices

Some practitioners of the public arts have renounced art objects altogether and developed a practice of enabling others to make work. This too has conservative

Still from *Battle of Trafalgar*, **Despite TV,** 1990/91. Despite TV, a video cooperative set up in 1983/84 in London's East End, providing cheap access to video facilities open to all members of the community. They attempted to demystify the machiniations of the media through training to members in all stages of video production. *Battle of Trafalgar*, commissioned by Channel 4, documented the national Anti-Poll Tax demonstration on 30 March 1990, examining the role played by the police. The programme provides evidence that the demonstration was mismanaged by the police who, it is claimed, caused the ensuing riots.

and libertarian variants. What does a software designer or hardware manufacturer do if not make it possible for thousands of consumers to make their own art, so altering the art experience from passivity to activity? The workshop principle differs in at least two ways: it doesn't demand cash up front from end-users relying typically on grants, and it looks to group rather than individual practice (though this is often vulnerable to shifts in funding policies).

This workshop sector includes more than the familiar access workshops in most cities and large towns in the UK. It embraces workshops offering training for access workers, such as London's Fantasy Factory (now closed down) in video, and Camerawork in photography; radio workshops like Local Radio Workshop and the Ariel Trust; computer agencies and facilitators like Artec and Soft Solution; the communication infrastructure offered by conferences, festivals and small publishing ventures; gallery and exhibition venues and the supports that exist for them like the Moving Image Touring and Exhibition Service in Liverpool; and the sometimes problematic services offered by regional and national funding agencies. The crossover zone between arts, media and training has often proved difficult for such agencies to manage, and leads groups to shift priorities according to funding policies and likely partnerships, notably

Still from the film *Seven Songs for Malcolm X,* directed by **John Akomfrah** and produced by the Black Audio Film Collective

with education and broadcasting. Shifting priorities can create major frictions with users, due to the confusion of cultural and employment aims, when workshops steer an ambiguous course between cultural politics and the equally laudable aim of providing skills that can get trainees a place in the industry proper.

Relating to this shift is a major pressure, both financial and status-oriented, towards product rather than process. The arrival of Channel 4, and BBC2's recent move into vanguard areas and new arts funding (while the British Film Institute has been unable to cope with the arrival of electronic media) have coincided with other distribution avenues, like community radio and the Internet, to suggest to practitioners ways of reaching a large public – though at the price of yielding the right to question either the institutions or the consumption of their works. The destruction of local democracy in most of Britain's large cities in the mid-eighties saw public support for public arts shift increasingly from emphasising the 'public' to emphasising the 'art', from access to prestige, from accountability to accountancy, and from future democracy to heritage industry. The increasing number of art-school courses in time-based media helps this drift away from an older practice associated with such unfashionable domains as therapy, social work and vocational training.

Some of the product of this art-school generation has managed to bridge the gap between the financial necessity of working with TV and the cultural specificity of working with a particular community. A prime example is the film and television work of Black Audio Film

Collective. Their 16mm productions like *Handsworth Songs* and *Seven Songs for Malcolm X* have challenged TV documentary procedures and the truisms of the avant-garde, drawing on the aesthetics of the African diaspora (rap, storytelling, rhythmic repetitions) to invent a mode of representing Black British experience that simultaneously explores that experience and demands of its viewers an engagement with how it has been and is being mediated.

A different approach was adopted by Copyart in the eighties, who combined research and development for the reprographic industry with their own art practice by delivering poster, dustjacket, record sleeve and video cover art for sympathetic individuals and groups. This stance takes on the centrality of marketing to contemporary culture as intelligently as Warhol, but puts it to a use beyond the merely aesthetic.

The founding principle of this body of work is that participants know better than commentators what goes on in the large scale political struggles of our times, and that cooperative practice is essential to developing an alternative form of communications.

Individualism and interaction

The first years of public media arts involved the need to work cooperatively to gain access to the fundamental tools of the medium at hand. In the early seventies a portapak was beyond most people's pockets, and editing facilities impossibly expensive. Today camcorders, palmcorders, MIDI systems, home recording studios, advanced graphic computers, modems, photocopying and even radio transmitters are cheap enough for many working class families.

At the same time, it has to be said that much of this equipment is poorly used, if we take as criteria for their use formal innovation, the voicing of otherwise unheard experiences, and the complexity of relationships with audiences: in short, the multiplication of differences. Home video, for example, tends to duplicate the limited roster of formats familiar from photo albums: even the arrival of video births scarcely upsets the apple-cart. What photo-album or domestic video is trained on funerals? Illness and death are two topics from which we stay away as a culture that locally controlled media are uniquely able to capture and explore. Yet, on average, they don't.

The new role of public media arts is then not to provide initial access, but a reason for producing works that escape from both the confines of the family circle, and the norms of production values

Peter Dunn, The Art of Change, *Tricks of the Trade,* digital montage 1992. *Tricks of the Trade* concerns trickster figures and associated cultural forms that have emerged out of the diaspora of the slave trade. The image itself is 'tricky'; a rebus pulling together a web of narrative around Anansi, the spider trickster of Afro-Caribbean popular culture. Like Anansi, the image itself takes many forms; as a A1 poster combined with a teaching pack, as a billboard project, and as the front-end image of an interactive CD Rom.

acquired from TV. This is the role of the horizon-expanding of artist-animateurs, as it is of new models of professional broadcast practice by groups like Black Audio. Most of all, it opens up the question of what it might be to make work for an audience beyond the immediate kin.

The concept of mediation helps to put centre stage the fact that media arts are by definition public. Such works only exist in relation to an audience. The problem is not simply what to make and how to make it, but crucially what happens in the movement from production to consumption – the arena of distribution. Oddly enough, as production equipment gets cheaper, distribution media get more expensive. Getting decent distribution means striking a deal with one of the big players in an increasingly concentrated marketplace.

The Internet offers one model of expanded distribution. On the positive side the Net is open to anyone who can get to a terminal, free of censorship (though there's lots of peer pressure on activities that don't fit in with the ethos) and in many ways more democratic than any other medium bar the mail. On the other, it's pretty much limited to the industrialised nations (though a new 'interperiphery' network is being established by Drik, the Bangladeshi photographic agency), still largely shaped by older media forms like the library, and though very sociable, it's a sociability dominated by the interaction of individuals.

I don't know if I'm alone in feeling that this individualism is the threshold at which the notion of public media arts has arrived to date.

Traditionally Leftists, among whom I count myself, are simply against individualism. But it seems now that the design of key distribution media as well as key production technology are profoundly individualist – personal stereos, computers, camcorders, MIDI music systems. But this tendency is only a new challenge, a new opportunity.

The question confronting the public arts, and most particularly the public media arts, is how to intervene in this sociological process in which the individual is more and more the main building block of society, but at the same time is clearly perceived to be a sociological phenomenon already in crisis. The problem with art undertaken in the public sphere, with its faint aura of social therapy and social work, is that though it may develop expressive powers in participants, we are always reluctant to tear down the fragile unity of the self that is being expressed. That is the kind of risk it is perhaps fair to ask of yourself, but not of others, relative strangers. The stiffness of much public media arts is a direct result. The new media, so addictive, so personal, so all-absorbing, speaks to users at the intimate level, the level of fantasy, or, for want of a better word, the unconscious.

The model of the computer game has proved one of the most exciting to date. Pete Dunn and Lorraine Leeson, who honed their skills on the Docklands Poster Project, have in their new guise as The Art of Change, produced an extraordinary interactive CD Rom which takes the player through the world of international debt and ecological destruction via the ancient myth of Anansi, trickster god and spider. A number of other artists have taken the already quite established future of the installation and begun to design it with electronic components and community input: the figures of computer memory and oral history already grace a number of the best museum and gallery uses of new technology, as in the Musée Beaubourg's photo project. Others hazard the choppy waters of interaction, like Simon Biggs' experiments in 1994 with local audiences helping produce, through an open studio set-up, the armature of an installation-performance called *The Living Room* in London's Truman Brewery.

Interactivity is, paradoxically, the most ancient and the most modern characteristic of mediation. What do media mediate between if not between people? Yet it is only now that artists in the public media are beginning to work with this fundamental concept. Much of the time, their concept of interaction is still developed as the simple negation of broadcasting's one-way street, and is shaped far too much by the opposition to TV. Really, a narrative in which you can choose between two endings is no more interactive than switching channels or choosing which film to see at the Odeon. It's certainly less

interactive than conversation. But such is the strangeness of the times we live in that it is necessary, and I believe essential, to reinvent the social. Designers of media products design them for individual consumption. Artists, far too often, speak of their art as individual production. Neither offers anything that is not entirely in conformity with the dominant and pernicious individualism of a Thatcher or a Reagan. Public media arts will have to give up its old presumption that community is right here. It may have been, but it isn't now. It will have to confront individualism, But only to go through it, and come out on the far side, into a new order of socialisation of which, as yet, we have not the slightest inkling.

Dancer **Rebecca Skelton** performing with the video projections of the interactive installation: *(i=0001; i<=1001; i++)* by **Tessa Elliot** and **Jonathan Jones Morris** at Camerawork, February 1995. *Photo: Dave Than.*

The title of the piece derived from a line of computer code implying that the audience (the body) completes the interactive element (computer-generated) of the installation. By standing in front of a surveillance camera the visitor changed lighting in the space and triggered off sounds and animation as well as creating a ghost image of themselves through a connected largescale video projection. So the viewer becomes integral to the creative process.

The project involved some 75 workshop participants making up seven types of user groups such as MA electronic arts students, dancers, school groups and adults with learning difficulties. The groups participated in a one-day workshop creating animations and sound which were incorporated into the installation. Elliott and Jones Morris were modifying the software, images and sound throughout the workshops. They worked with performer Rebecca Skelton and composer Andrew Deakin to make optimum use of the sound and interactive elements of the work. The final piece was directed and produced by Elliott and Jones Morris in the same way a film might be made. But throughout the emphasis was on audience and participants (on whom the piece depended for its existence). The final installation was a completely collaborative piece which made a significant contribution to the field of computer-generated interactive media and combined arts practice.

10 • Challenging freedom

Adam Geary In the catalogue which accompanied the 'Art for Whom' exhibition at the Serpentine Gallery in 1978, David Binnington wrote, "The artist's only value is as an example of freedom, but the freedom given is the freedom to be irrelevant."

On reading this statement after several years, I recalled my first exhibition experience at Transmission Gallery, Glasgow in 1987. Having just left college I was full of new ideas and confident in the ability of my art practice to communicate to a large audience. While sitting in the quiet gallery however, it felt as if I was waiting for an audience that would never come. Finally, out of boredom and a kind of desperation I picked up a handful of leaflets and left the gallery to confront an unsuspecting public on the street. The leaflet – *The Promise of Tradition* – drew attention to the corrupting influences that tarnish our parliamentary democracy. It had been carefully designed and formed an integral part of one of my installations. Slowly, due to my efforts, people started to drift into the gallery. But it was the act of giving this leaflet to people on the street that had energised me.

After the exhibition, the small intervention with the leaflet became the turning point for my art practice, leading me to analyse what it was I was trying to achieve through my work. From this point on the gallery ceased to have any relevance for the issue-based work I wanted to pursue, as I knew such spaces would be unlikely to attract the large audiences I was trying to engage.

If my work was to have any social relevance, it became clear that I needed to target projects to specific groups and involve myself in every aspect of the planning, production, distribution and promotion of such work. The idea was to keep producing my own work, but also to get into a position where I could begin to introduce and promote the type of work that I felt was of relevance to the communities where I was working.

Being a photographer and having picked up a good knowledge of the design process, I began to work on print media projects that

"Projects are initiated by myself and themes emerge from pilot workshops with the specific group. On average three workshop sessions lasting three hours each will result in a clearly focussed theme and draft design for one poster. The next phase involves design work on computer. The production time of designs going through stages to print is integral to the process. We then devise strategies for distribution through formal and informal education networks, local and regional youth services and individual distribution by those involved."
Photo and quote: Adam Geary.

were relatively cheap to produce and distribute. The poster format fitted the bill, providing me with a wide range of creative opportunities. Largely due to the feedback received from such projects, I began to use the poster as the basis for developing workshops in a range of formal and informal educational situations. The power of the poster lies in its ability to create a focus for issue-based discussion and analysis. This line of questioning now forms the core practice of my activity.

Much of my print media work functions within an oppositional framework at the point where the arts and campaign advertising collide. Most of the projects I've organised or produced have been designed to interrupt the flow of images and signs distributed through mainstream media; presenting both myself and those who work with me with an opportunity to confront and question a wide range of issues and concerns.

Since that day in 1987 when I took to the streets to promote my work and ideas, I've tried to develop a socially relevant practice. This has seen me work as an independent arts/media producer and arts administrator. To this end, I've held three full-time posts in the arts, culminating in my present post as Arts Officer for Maidstone Borough Council. Running parallel to this work have been my activities as Prolific Pamphleteer, a print media production company I set up in 1988 to produce and publish a range of written and visual educational materials on culture, the arts and contemporary social issues. Through these combined activities, an arts practice has emerged that is critically engaging and grounded in the needs of various communities I've chosen to work in/for.

Cause/Effect, by **Adam Geary** was a commission for Oxford Artweek in 1992. *Cause/Effect* was produced as a series of 'ads' in double decker buses as well as a series of posters. The work was a grossly ironic response to Oxfordshire County Council's way of dealing with the 'riots' on the Blackbird Leas estate. The 'riots' centred round joyriding so the council put humps in the roads.

A low-cost technique was used to generate excitement and highlight the quality of the environment.

A wide range of facilities were provided to cater for the needs of the local community.

Most projects have had a strong educational bias, creating opportunities for people to plan and produce poster campaigns and/ or other print media initiatives. Participants have been given a vital opportunity to find and raise their voice. Through the act of planning and producing a poster or other print media project, they've been able to learn new media skills allowing them to make coherent and thought provoking comments about their lives. Much of the work has been with young people and has proved, at times, to be controversial, and at others, extremely positive and rewarding. What all of the projects have in common is the opportunities they have created for young people to learn new skills and importantly, for their opinions to reach a large audience and be taken seriously.

What is hopefully clear in all this is the need for arts/media producers and organisations to be more energetic and creative in the way they promote and develop their work in this challenging economic and political climate. The arts, if they are to have any relevance in society, must begin to address themselves to the communities in which they operate. A shift needs to be made towards promoting high-quality, critically-engaging practices that use the arts and the benefits of new technology to create opportunities for people to find and raise their voice. If this happens, the freedom given to the independent arts/ media producer will be called into question, but this time because what they do with this freedom will be challenging and of great 'relevance' to the wider community.

Art Zombies,
Ross Sinclair,
Ben Allen and
Mark Pawson,
installation at the
Catalyst Arts
gallery, 1994.

Over the past two years a growing number of artists
working in Belfast have been concerned by the low profile
given to visual art and the cultural climate within which
they work. It seems that a limited form of art is being
produced for a small number of outlets and being seen by
an élite minority audience. The major funding body's
approach is retrospective and its grant system constructed in
such a way as to divide artists, and promote competitiveness

and the worst traits of individualism. Attempts at collective organisation sit uneasily within the competitive framework of studios and galleries.

Recent artist-initiated exhibitions in non-gallery spaces in Belfast and Holywood aimed at alleviating this situation made it clear that there was need for a permanent gallery venue which could continue this surge towards a culture of cooperation. This has resulted in the formation of Catalyst Arts which now occupies a former shirt factory in Exchange Place in Belfast. This comprises gallery space of 1500 square feet with open plan studio space (accommodating at minimum three artists) on one floor and an office facility upstairs. After several group projects and the establishment of Catalyst Arts as a charity, we now receive a small contribution from the Arts Council of Northern Ireland.

Exchange Place is intended to be a centre for experimentation and in that we offer a flexible and multi-purpose space. Our aims include the involvement of the public in a more broad-based approach to the visual arts by means of exhibitions, lectures and community workshops; to provide a neutral venue for community arts activities; to provide space and support for the presentation of one-off projects from a broader range of art activities including performance, music, literature, with openness to proposals from artists outside of the immediate membership. The project has already established links with other artist-run spaces and organisations and as a development of that we hope to promote an exchange programme on a national and international level. This has already taken place with artists groups from France, Budapest and Glasgow.

Exchange Place is a centre for experimentation, contemporary debate, and supports the quest for unconventional means of expression, beyond the boundaries of four white walls. We are run by and for artists. We don't exist to support any one notion of what art is or to please anyone in particular. We are non-partisan, resolutely not the stomping ground of a new clique.

11 • A working story

Gillian Steele After working for two years with an artists' collective, an opportunity arose of some voluntary work with a community arts project. It seemed to me a move into this area would allow a leap from what I saw as a dysfunctional occupation within a gallery context, to one where I might be useful and my skills required.

It wasn't long before I woke up to the full extent of the banalities which huddled beneath the threadbare umbrella of community art. The 'we just want you to do something with them' attitude, coupled with notions of 'recognition of self on screen' workshops (which got called video projects) lead me to initiate my own ideas. These I put into practice by making a proposal to an organisation who had funds to commission work; by making a proposal through another organisation who then took percentage for administration costs; or by direct invitation from host organisations. I also responded to requests from local authority organisations to run workshops. Though the informal set-up allowed me to invent and re-invent my approach, the assumptions about artist and group were often a source of great instability. A typical art school training seldom prepares you for counter-productive practices such as:

- being given a group of eighteen young people, one video camera, minus the appropriate leads, no tapes, a dodgy tripod and a helper no more qualified than me to deal with large numbers of young people.
- being given a space which is neither adequate nor appropriate for the work.
- having a budget for materials no one tells you about and no way of getting materials without considerable effort in your own unpaid time.
- being put in a situation where you require the combined skills of a psychiatric nurse, a drugs counsellor, an intermediate training worker, and a magician.

Children from Hollybrook School Glasgow working with **Gillian Steele** on an animated film. "I didn't want to use the word animation in case it made them think they were going to produce Aladdin. Hopefully at the end of the day we'll have this result and they'll just be astonised." *Photo: Chris Hill.*

• an unreasonable number of people being herded onto your project despite your advice to the contrary.

Within Strathclyde, Region Community Education (Com-Ed) workers encourage groups to venture into new areas of discovery. Often the method of learning chosen by the group is arts based. As yet though Com-Ed have no policy or guidelines about use of art practices. Broadly speaking, it's supposed to be another means of encouraging involvement, a sense of achievement and confidence building. Perhaps because of the absence of any specified strategy many Com-Ed arts projects seem to be relatively unproductive.

It's surprising to learn that many inviting organisations value consultation as an exercise, yet expect it for nothing from artists, and then ignore it when they get it. This results in money being poured into projects whose success from the outset is uncertain. Despite initial claims to value 'process' above all, it appears at times that organisations expect nothing to be achieved in terms of improved quality of life for their groups (putting into sharp relief their high expectations of the artist) but everything in terms of an end product. At the end of the day it's end-product and its quality which proves the success of a project and secures funds for the next one. That's hard to swallow when you're running around trying to make it happen for eighteen people

who come bottom of the list. Artists could be forgiven for thinking that we are being drafted in like a gentle kind of policing – you know the way that art at school really meant 'somewhere to put them'.

It's a great pity so much energy needs to be spent on changing attitudes of inviting organisations, rather than exploiting the creative potential of working with people. Perhaps training on raising awareness among workers about how arts projects can dovetail with their own aims and objectives would be useful.

The working process

In 1993 I started working with a women's group who wanted to make a short film. I found my work was an integrated part of a workplan and of larger issues being tackled by the group under the guidance of their Com-Ed worker. Being given an overview helped me to see how our work together could contribute to the larger plan. I also had the opportunity to raise any problems, ask for advice and deal with practicalities. The resulting work *Safeplace*, a film about parenting and young people, reflected this spirit of integration. The film was received well by local people. A screening resulted in an interesting discussion between the makers, local police, carers and other interested parties, and one organisation requested copies for training purposes.

The kind of groups I've worked with have usually been decided by the nature of the proposed work, and consultation with the relevant host organisation. *Animate Her* for example arose from a proposal in 1990 to an artists' commissioning group to use animation to raise issues of sexism faced by young girls. I targeted a group in an area of multiple deprivation because I felt poverty and unemployment worsen an already unequal situation for the young girls and women.

It's not always possible for me to suggest the most appropriate group and most organisations take the sensible approach of targeting those who benefit most from a project. But this is never as straightforward as it could be. The 'right' group may be passed over because insufficient numbers respond and the organisation won't justify spending money on the few who do turn up, regardless of enthusiasm. Sometimes it is responding to a project at all which is the stumbling block. The beginnings of a tape-slide project in Castlemilk, a housing estate in Glasgow, in 1994 served to show that often the most appropriate groups are also the most difficult and evasive ones.

Cooperations Wiltz is an artist-run organisation working with marginalised groups in a unique and progressive way. The artists running workshops work on a one-to-one basis to enable participants to produce artworks of a professional standard. This highly unusual method of working places the less-experienced artists participating in the workshops at the centre of the creative process, the professional artists acting as enthusors and enablers. In July and August of 1993, through the Glasgow photography gallery, Street Level, artists Anne Elliot and Brian Jenkins travelled to Wiltz in Luxembourg to work with artist Patricia Wohl and a group of artists – Yves Zouval, Claude Thinns, Raymond Jacoby and Robie Kops – from Ettlebruck over a six week period. As part of the project two artists from the Scottish Association for Mental Health – Samuel Johnston and Stephen Campbell – worked with the group for one week continuing their work on their return to Glasgow. The exhibition shows the work of people whose art practice has developed as a result of the Cooperations project. It is, nonetheless, indisputably their work; it varies enormously, with different approaches to the lens-based medium, from drawing using the cyanotype process to more traditional methods of photography.

Through the Arts and Culture team at Strathclyde Regional Council, Elsie Mitchell (who had been artist-in-residence for Castlemilk in 1993) and myself approached some groups. One – the Unemployed Workers Centre – accepted the invitation with enthusiasm. But in the first few meetings the group didn't turn up, or arrived late and left early. As we were dealing with the long-term unemployed it was possible that the problem was time structuring. This could have been ironed out with a few more weeks, a new approach and full support from staff at the centre. Because of the way the project was funded though, it had to start soon. So the invitation was passed onto the Scarril Terrace International Family Centre. The group of Malaysian women there found the structure of weekly meetings no problem. Possibly because their lives were shaped around weekly social meetings, sewing and English classes.

The group set out to create a work combining photographic and hand-drawn slides. Teaching them to load the camera, set the lights and take a portrait shot encouraged new members to the group, because this was considered to be technically skilled, unlike hand-drawn slides which were considered to be child's play. The greatest difficulty I found was in communicating to them the worth of what we were doing and the potential for expression with the slides and the soundtrack. However, the group evolved as a discussion circle where issues were raised and explored, then reassembled as the parts of a piece of work we called *Pictures from the Pocket*. My role was to collect those parts and bring them together as a unit. The working

process, which included the fun and conversation, were not considered by the women involved to be a valuable part in making the work. But they were filling my notebook with ideas on how their feelings might be conveyed to an audience and despite the group's suspended disbelief in this process, they valued the work when they saw it in its finished form.

It is true that anything but an informal approach to this work would have made it laboured if not impossible. However, like most groups, the women brought along their own set of limitations, the first of these being the assumptions that people have about themselves. In the case of the tape-slide project, the limitations seemed to be set by religion and culture. One woman, who tended to be the group's spokesperson, said to me, "You know, we're just housewives. We don't understand mystical things. We're only good at cooking and sewing...." Although these are obvious skills to be valued, this 'doctrine' did not reflect the interests of the whole group, yet still influenced their behaviour.

What is work?

Another limitation concerns ideas which many people have about what art practice is. Most people still think of work as being something that makes you sweat, isn't fun and that the end product should reflect this. But I consider that there is very little which cannot be considered part of the working process given the right intent. It is the 'intent' part which is so difficult to elicit from many groups, who are used to the authoritative 'lead me by the nose' approach of schooling. In many ways what artists in the community do has to follow on from and be a part of a re-educative programme put in place by community education workers, whose job is to encourage training in organisational skills, initiative and devolvement of power from them to their groups.

I think there are a number of ways in which the work artists do can be made to be a more integrated and useful part of community work. The first might be to pay them for consultation and then make use of the advice they have to offer. Other areas include allowing for sufficient hours to carry out the work; providing adequate space to work in; providing the appropriate skilled support workers; and accepting that making a wonderful piece of work with a group of four is more cost effective than a shambolic rabble, on a similar budget, with a group of eighteen.

Musafir, from **Cultural Transmissions Network's** multimedia exhibition and on-line residency at Rochdale Art Gallery, 1994. *Photo: CTN.*

Cultural Transmissions Network is a collective of practitioners involved with arts administration, project development, media marketing, electronic art, environmental sound production, design and moving image. Collaborating with agencies around the North West region, CTN is proactive towards the establishment of a resource, and access to facilities for the experimentation and dissemination of artistic work utilising electronic new media technologies.

Cultural Transmissions Network was initiated as a result of the constant marginalisation and misrepresentation of Asian and Black artistic practitioners within mainstream institutions. Influenced by historical legacy and contemporary issues, CTN has developed its creative parameters to become a social interface for the individual and collective experience of the Asian and Black communities resident in Britain today.

Successfully commissioned by North West Arts Board and Manchester City of Drama in its commitment towards the emergence of innovative Asian and Black work within the region, CTN exhibited 'Musafir – Voyager' at Rochdale Art Gallery. 'Voyager' was an exhibition which reflected the

experiences of migration, cultural legacy, and the contemporary concerns of Asian and Black people resident within a eurocentric culture.

During Cultural Transmissions Network's residency at the gallery, CTN practitioners stimulated the public's awareness by way of seminars and open workshops. Utilising video monitor installations, projections, sound narratives, and computer graphics, 'Voyager' enabled CTN to advocate the application of consumer multimedia technologies in empowering communities to readdress issues of cultural identity, unemployment, education and urban regeneration.

Cultural Transmissions Network's intervention within the North-West has given rise to questions surrounding the élitism of modern day art practice, its social purpose and the function and accessibility of art to the Asian and Black communities. In creating a positive platform in addressing the lack of representation by art based establishments of Asian and Black work and audiences, CTN is currently producing live on-line multimedia performances within club environments. CTN's creative use of new media technologies within these venues has given rise to introducing electronic cultural art to a new generation of audiences from differing class, economical, political and racial backgrounds.

12 • Community arts development

Lee Corner In 1976 the Arts Council of Great Britain prefaced a report: "...the objectives and practice of community arts are consistent with the Council's chartered duties.... The Council has unequivocally affirmed that community arts comes within its scope of funding."

The following year funding was devolved to the regional arts associations since it was believed community arts, having a predominantly local remit, was best assessed and funded regionally.

The significance of the Arts Council statement was that the major national arts funding body had been persuaded to accept responsibility for the support of an activity based on a way of working rather than on an art form. This achievement, some believe, was in no small part due to the resistance by its practitioners to define the activity called 'community arts'.

Community, Art and the State: Storming the Citadels, Owen Kelly, Comedia, 1984

Owen Kelly wrote, "Community arts was woven... from three separate strands. Firstly there was the passionate interest in creating new and liberatory forms of expression, which the Arts Labs both served and fuelled. Secondly there was the movement by groups of fine artists out of the galleries and into the streets. Thirdly there was the emergence of a new kind of political activist who believed that creativity was an essential tool in any kind of radical struggle."

The period was the late 1960s and early 1970s. Many of the groups and individuals engaged in these activities were as interested in an alternative society as they were in art. They were also realistic enough to recognise that state funding – albeit through the 'arm's length' Arts Council – was more likely to be forthcoming for art than for social change. So there were pragmatic reasons for avoiding close definitions.

But in the absence of a definition by the practitioners, funding bodies inserted their own. Often they focused on two essential ingredients of community arts – participation and location – and used them as the basis for initiating and supporting projects where the arts could fulfil some useful social function. The mid 1970s saw an

115

Hookey and proggy workshop in Tyneside, 1981, set up by **Uncle Ernies**. Work like this shares skills in making artefacts born out of a particular cultural situation. Where does the 'value' of this lie, as a form, in relation to the products say of a designer like William Morris?

explosion of mural projects on housing estates and arts work in hospitals, probation centres, prisons, factories, day centres.

Friends and allies

The community arts movement raised questions about the role of the arts in society. In doing so it opened up debates such as why it was assumed that some forms had greater value than others (opera versus panto); why the means of production and distribution were in the hands of the few rather than the many; why people in certain 'disadvantaged' situations had few if any opportunities to hear and see – let alone make – art.

These questions struck chords with a far wider spectrum of people than those originally engaged in the movement and it became increasingly difficult to identify a common political ideology. For some

people the motivation was to make the privileges of the élite available to everyone: seeing an opera or production of Shakespeare – learning ballet or the violin. For others the motivation was in giving value to, and gaining recognition for, the cultural expression of 'ordinary people' – the youth group video; miners' wives review; book of reminiscences by elders.

Adult educators, teachers, carers and community workers were amongst those who made links with artists and arts workers. It soon became clear that the 'friends and allies' of this kind of practice were more likely to be outside than within traditional arts institutions.

The keywords became access and participation. The arts worker's role was to facilitate and enable, to draw out the skills and talents of those participating rather than to teach or impose. The settings were places where people naturally congregated and the catchment was local. The art form or forms were chosen for their appropriateness to the interests of the group or the desired outcome.

The funders' response

Community arts received a fairly mixed reception when it was devolved to the regional arts associations. Where there had been substantial activity in the early years, where there was a backdrop of political activism, or where RAA officers were sympathetic to the ideological foundations of the activity, projects and organisations flourished. The West Midlands, Yorkshire and the North West were three notable areas. Here community arts not only found support within the RAA but its practices informed both the thinking of specialist art form officers and the design of art form specific projects and schemes.

In her *Review of Community Arts in North West Arts* in 1990 Cliodhna Mulhern writes that they were, "...the first RAA to create a Community Arts Department (1979).... 'Community Arts' was a product of the social revolution of the sixties. Hitherto there had been art (high and professional); hobbies (amateur arts activity); popular entertainment; and activities which were not art (photography). The seventies was the decade of 'community'. Community workers; community education; community nurses; and of course community arts. Notions of self-determination, democracy and equality underwrote all this new thinking. Arts institutions had not reflected these interests in the past – so NWA's new Community Arts Department had a clear purpose quite distinct to that of other NWA departments. *Planning for*

the Arts [the 1983 policy statement] presaged a change in the role of arts departments by emphasising access. All departments began, to different extents, to support community involvement in arts activity. By 1986, only three years later, the specific role of the Community Arts Department was less clear."

The activity and its motivations found further support amongst many local authorities at a time when links were being made with RAAs. Joint initiatives on housing estates, eg for summer playschemes, with single parent groups, served the need for councils to provide for their constituents and the need of arts funders to promote access to the arts. The benefit to the community arts group was a more diverse, and so less vulnerable, funding base.

Into the nineties

Community arts as a term was relevant enough in 1991 for the Arts Council to commission a discussion document for the National Arts & Media Strategy. Yet the views and practices described there illustrate an enormous range of motivations from "cultural banditry for the redistribution of cultural goods" to "mixed economy job and wealth creation schemes".

Even though a number of contributors to that document either reject the term 'community arts' or signal discomfort by prefacing it 'so-called', what each describes is some form of participatory community-based activity. The common threads continue to centre on people being given opportunity, skills and resources to make their voices heard. On issues, in fact, of empowerment.

In the mid-1990s it is not easy to find a funding body which responds immediately to the term community arts. Phone any regional arts board or arts council and ask about grants for community arts projects and you are likely to be asked to specify the art form (visual art, music, drama) or the bit of the community (school, hospital, black, disabled). You are unlikely to be put through to the community arts officer or to tap into a community arts budget. In this regard the world has changed considerably in the last half decade.

But if you press an RAB for its policy it may well explain that the absence of an appropriately titled officer or budget head signifies not the demise of support for the practice but the assimilation of its principles into all areas of the organisation's work. So, it is argued, access and participation underpin the composer in the community, writer in residence, and arts education schemes, and the prevailing ideology is empowerment.

What next?

Recent arts funding crises have focused attention on the needs of mainstream (often building-based) organisations. But it's hard to prove that art with people is diminishing as a funding priority.

As central government funding has decreased so funding responsibilities have had to change. Logically, the argument goes, that which is national should be funded nationally, that which is regional regionally and that which is local locally. At a national level the emphasis is on programmes of outreach, education and touring by mainstream companies and venues. At a regional level we find policies and organisations with a specific brief: rural arts, arts in hospitals, arts in schools. Increasingly the work which was the mainstay of community arts twenty years ago – the arts workers on the housing estate – is most likely to receive its major support from the local authority.

The same period of change has also witnessed the demise of many of the pioneering community arts groups. New independent groups appear to be a thing of the past. In their place have emerged local authority arts teams – multi-disciplinary units with skills both in 'doing' (the youth group video, the community play) and in 'facilitating'.

There is a handful of groups (some with their roots firmly in the political soil of the seventies) who are evolving their practice to meet the needs and aspirations of participants in the nineties. Their commitment to empowerment, to shared decision-making, and to providing the means of production and distribution is still at the core of everything they do. But they have recognised people (the young especially) have developed more sophisticated understanding and expectation of cultural goods. They are at home with high-quality images and sound reproduction; they are comfortable with electronic equipment and the new technologies; they respond to the kinds of surroundings they find in multiplex cinemas and game parks.

One of the most dramatic manifestations of such developments is Jubilee Arts' proposal for a Digital Theme Park on the 'banks' of the M6 in the West Midlands. "A concept combining economic regeneration, arts and investment in the community", the proposal has inevitably captured the imaginations not just of the local authority and the RAB, but of private developers and commercial concerns.

"Community arts has come of age and there is nowhere in the country providing any central focus. In partnership with the Regional Arts Board and the Arts Council of England we can provide a centre of excellence for community arts....

From new technology to newer, **Jubilee Arts** working with black and white Sony video in the early eighties (above) and (right) workshops in 1993 for *Sex get Serious*, a computer multimedia package about HIV/AIDS created with Sandwell Health Authority. *Photos: Jubilee Arts.*

"Technology is here and it's growing. Jubilee has been fortunate to have developed sought-after skills allied to new technologies, with strong roots in community development practice. As a keynote speaker to the Apple Multimedia Conference in San Francisco three years ago stated, 'The 21st century belongs to a dynamic collaboration between the techies and the creatives, something never envisaged

before, a true welding of science and the arts....' Local communities are the third side of the triangle."

Jubilee's vision is significant in two regards. First, it illustrates how practice can lead funding policy rather than be its victim. There are, inevitably, dangers: those whose practice is not so innovatory might find the funding pot even emptier if funding follows fashion.

The second point is of particular relevance to visual artists. With the exceptions of the odd banner and the ubiquitous printshop, much community arts practice has focused on the performing arts – music and drama particularly. As they used to say: "You can't throw a pot with a political message so what's the point of throwing pots?" Yet the core of contemporary community and participatory arts is, increasingly, the visual image – through photography, film, video, print and design. No longer is the visual artist relegated to painting the backdrop for the fireshow and leading the mask-making workshop.

Working the system

The chartered objectives of the Arts Council, accepted by the arts funding system, are as follows:

- developing and improving the knowledge, understanding and practice of the arts
- increasing the accessibility of the arts to the public throughout Great Britain
- advising and co-operating with departments of government, local authorities and other bodies.

While access remains an objective there will be money for art with people, even though it may be tied up in specific schemes and there may be fewer flexible or responsive budgets.

As far as local government is concerned there is little evidence that funding constraints on local authorities will ease in the foreseeable future. Project grants are still available in most areas for work with local communities, and some revenue provision for in-house community arts groups or independent bodies looks likely to remain where they are delivering priority services to local residents.

Of the major trusts and foundations, the Gulbenkian Foundation has maintained a commitment to local action from its pioneering support of community arts in the seventies. In its programmes for rural development and cultural equity, support is available for projects involving groups of people, communities of location or interest, in

making their own culture, with or without assistance from professional artists.

The practices of community arts have never been more diverse or fragmented. In the absence of commonly agreed methodologies (or even principles) among practitioners, funders have filled the gap with projects and schemes which fulfil their own strategic needs. This need not be bad news. The pragmatic artist will work within their guidelines. Opportunists will reshape their idea to the scheme which looks most like it. The visionary will come up with something which moves the boundaries. The successful artist is a bit of all three.

13 • Contacts

As there are hundreds of community arts groups around the UK it's not possible to provide a comprehensive list here. Those listed below, however, give an indication of some of the work going on nationally. Also listed are national arts councils, regional arts boards, selected courses, some sources of grants, advice and information and some of the professional bodies whose work is relevant to the book. For more information on artists and groups in a particular area, contact the relevant arts council or board. Training opportunities are often listed in *Artists Newsletter*, but also check what's offered by adult education departments, the local council for voluntary service and local arts development agencies.

Environmental & health agencies

Artlink, 13a Spittal Street, Edinburgh EH3 9DY, tel: 0131 229 3555. An arts development organisation, Artlink has extensive knowledge and experience of working in cooperative partnership with people with disabilities. Artlink develops participatory arts programmes in hospitals, resource centres and in the community. They are complimented in the Strathclyde Region by Project Ability based in Glasgow.

Common Ground, 45 Shelton Street, London, WC2H 9HJ, tel: 0171 379 3109, contact: Sue Clifford. Through development of projects which encourage communities to commission sculpture, it promotes the importance of cultural heritage, local distinctiveness and links with the past.

Groundwork Foundation, 85-87 Cornwall Street, Birmingham, B3 3BY, tel: 0121 236 8565, contact: Information Officer. Has encouraged development of forty two independent Groundwork Trusts dedicated to working in partnership with others to regenerate local environments in places damaged by past industrial actions. Many are involved in visual arts activities.

Artist-led organisations

AFTER, 804 Manchester Road, Castleton, Rochdale, OL11 3AW, tel: 01706 31834, contact: Paul McLaren/Paul Hayward. Artists for the Environment in Rochdale runs workshops and events with a social, ecological, economic and historical emphasis.

Art of Change, Level 3, Lion Court, 435 The Highway, Wapping, London, E1 9HT, tel: 0171 702 8802, contact: Peter Dunn. Formerly the Dockland Community Poster Project, work now includes projects which enable communities to communicate their concerns and which raise awareness of the environment.

Arts Resource, 21 Foyle Street, Sunderland, SR1 1LE, tel: 0191 510 0916, contact: Deborah Hunter. Generates opportunities for artists and links proposals with sites, partners or funders.

Artscope, 24 Douglas Gardens, Dunston, Gateshead, NE11 9RA, tel: 0191 413 5340, contact: Malcolm Smith/Steve Marshall. Generates workshops and artworks which encourage participation in visual arts by people who have disabilities and others who have limited access to mainstream arts activities.

Artsquad, St Stephens School, Northumberland Road, Dublin 4, Ireland. "Established in 1990 with funding from FAS (Training and Employment Authority) its forty artists from diverse disciplines work part-time on community projects. Primary aim is to bring benefits of the arts to a wider group of people by placing artists in schools and hospitals, with community groups and voluntary trusts, and in this way activate the creative talents within the community." Nuala Hunt, 'Taking to the Street', *Mailout*, Feb/March 1992.

Black Arts Alliance, 111 Burton Road, Withington, Manchester, M20 1HZ, tel: 0161 445 4168, fax: 0161 448 03398, contact: SuAndi.

Chrysalis Arts, Old Council Depot, Eshton Road, Gargrave, N Yorks, BD23 3SE, tel: 01756 748042, contact: Rick Faulkner/Kate Maddison. Undertakes commissions for permanent and temporary visual arts projects, celebratory events and street theatre.

Company of Imagination, PO Box 328, Hetherset, Norfolk, NR9 3PU, tel: 01603 507197. Multi-artform group linking art and the environment and working in rural communities.

Freeform Arts Trust, 68 Dalston Lane, London, E8 3AZ, tel: 0171 249 3394, contact: Martin Goodrich/ Barbara Wheeler-Early. Committed to helping communities to improve their visual environment through development of art in public places projects including landscape design and architcture.

Freeform North Tyneside, Fish Quay Design Centre, North Shields, NE30 1JA, tel: 0191 259 5143, contact: Richard Broderick. Teams of artists work with the community on schemes to improve the urban environment.

Horse & Bamboo, Victoria Works, 679 Bacup Road, Waterfoot, Rossendale, BB4 7HB, tel: 01706 220241. Multi-form company creating live art performances and temporary events based on an annual horse-drawn tour around rural areas.

Pioneers, Old Library, Trinity Street, Cardiff, CF1 2BH, tel: 01222 222933, contact: Nick Clements. Generates commissions and residencies in South Wales.

Projects Environment, Three Springs, 42 Lodge Mill Lane, Turn, Ramsbottom, BL0 0RW, tel: 01706 827961, contact: Celia Larner/Ian Hunter. Investigates and develops ways in which artists and others can use creativity to address world urban and rural crises.

Raku Works, Mercer House, Mercer Park, Clayton-le-Moors, Accrington, BB5 5NZ, tel: 01254 391412, contact: Mags Casey. Runs projects which involve a high degree of community input to the design and making of ceramic pieces for public places.

Site Insite, Meadowmill Studios, West Hendersons Wynd, Dundee, tel: 01382 22124, contact: Chris Kelly/Chris Biddlecombe. Undertakes commissions in the community which are concerned with sympathetic and sensitive development of urban space.

Start Studios, High Elms, Upper Park Road, Victoria Park, Manchester, M14 5RU, tel: 0161 276 6345, contact: Jack Sutton. Undertakes community environmental art projects for sites outside hospitals in Manchester and creates opportunities for members and artists to undertake paid work in community settings.

Valley and Vale, Blaengarw Workmens Hall, Blaengarw Road, Blaengarw, Mid Glamorgan, CF32 8AW, Wales, tel: 01656 871911, fax: 01656 870507. Community arts team which has been working in Ogwr since 1982. Runs workshops in video, photography, dance, drama, animation, desk top publishing and design for people of all ages and abilities. Organises large-scale international festivals and performances; publishes books; creates exhibitions and community dance and drama performances; street events and mammoth community plays like *Ark*, in partnership with local people.

Welfare State International, The Ellers, Ulverston, Cumbria, LA12 0AA, tel: 01229 581127, contact: Sue Gill. Multi-art form group specialising in celebratory events and other temporary manifestations.

Arts councils and boards

Arts Council of England, 14 Great Peter Street, London, SW1P 3NQ, tel: 0171 333 0100. Funding in England now devolved to regional arts boards.

Arts Council of Northern Ireland, 185 Stranmillis Road, Belfast, BT9 5DU, tel: 01232 381 591.

Arts Council of Wales, Museum Place, Cardiff, CF1 3NX, tel: 01222 394711.

Crafts Council, 44a Pentonville Road, London, N1 9HF, tel: 0171 278 7700.

East Midlands Arts Board, Mountfields HouseForest Road, Loughborough, LE11 3HU, tel: 01509 218292. Covers Leicestershire, Nottinghamshire, Northamptonshire and Derbyshire except High Peak District.

Eastern Arts Board, Cherry Hinton Hall, Cherry Hinton Road, Cambridge, CB1 4DW, tel: 01223 215355. Covers Bedfordshire, Cambridgeshire, Essex, Hertfordshire, Lincolnshire, Norfolk, Suffolk.

London Arts Board, Elme House, 133 Long Acre, London, WC2E 9AF, tel: 0171 240 1313. Covers Greater London.

North East Wales Office (Arts Council of Wales), Daniel Owen Centre, Earl Road, Mold, Clwyd, CH7 1AP, tel: 01352 758403, fax: 0352 700236.

North Wales Office (Arts Council of Wales), 10 Wellfield House, Bangor, Gwynedd, LL57 1ER, tel: 01248 353248.

North West Arts Board, 4th Floor, 12 Harter Street, Manchester, M1 6HY, tel: 0161 228 3062. Covers Cheshire, Greater Manchester, Lancashire, Merseyside and High Peak District of Derbyshire.

Northern Arts Board, 9/10 Osborne Terrace, Newcastle upon Tyne, NE2 1NZ, tel: 0191 281 6334. Covers Cleveland, Cumbria, Durham, Northumberland and Tyne & Wear.

Scottish Arts Council, 12 Manor Place, Edinburgh, EH3 7DO, tel: 0131 226 6051.

South East Arts Board, 10 Mount Ephraim, Tunbridge Wells, TN4 8AS, tel: 01892 515210. Covers Kent, Surrey and East & West Sussex excluding Greater London areas.

South East Wales Office (Arts Council of Wales), Victoria Street, Cwmbran, NP44 3YT, tel: 01633 875075.

South West Arts Board, Bradninch Place, Gandy Street, Exeter, EX4 3LS, tel: 01392 218188. Covers Avon, Cornwall, Devon and Dorset (except Bournemouth, Christchurch and Poole areas), Gloucestershire and Somerset.

Southern Arts Board, 13 St Clement Street, Winchester, SO23 9DQ, tel: 01962 855099, fax: 0962 861186. Covers Berkshire, Buckinghamshire, Hampshire, Isle of Wight, Oxfordshire, Wiltshire and the Poole, Bournemouth and Christchurch areas of Dorset.

West Midlands Arts Board, 82 Granville Street, Birmingham, B1 2LH, tel: 0121 631 3121. Covers Hereford & Worcester, Shropshire, Staffordshire, Warwickshire and West Midlands.

West Wales Office (Arts Council of Wales), 3 Heol Goch, Carmarthen, Dyfed, SA31 1QL, tel: 01267 234248.

Yorkshire and Humberside Arts Board, 21 Bond Street, Dewsbury, WF13 1AX, tel: 01924 455555. Covers Humberside and North, South & West Yorkshire.

Courses

Selected list of courses relevant to this book.

Artists in Schools (Diploma of Credit), Anglia Polytechnic University, East Road, Cambridge CB1 1PT, contact: Julian Jarvis. Designed for artists of all disciplines wishing to train to work in schools. Part-time course open to all artists in the Eastern Arts Board region offers opportunity to aquire basic marketing and presentation skills; learn to design and implement projects for schools residencies; and gain practical experience of working in schools.

BA Hons Art & Social Context, Faculty of Art Media & Design, Kennel Lodge Road, Bower Ashton, Bristol, B53 2JT, contact: Sally Morgan. Three year degree offering fine art-based education for students wanting to make art themselves and work with people or in response to everyday settings. Encourages a questioning approach to role and purpose of art. Based on belief art can be means of creative expression open to all and is designed to question mainstream practices. Inolves studio work and placements.

BA Hons Environmental Art, Glasgow School of Art, 167 Renfrew Street, Glasgow, G3. Three year course which responds to enormous development of public art practices in recent years and to increased opportunities for artists to make more direct contribution to social, cultural and physical environment. Aspires to notion 'context is half the work'.

Hons Degree in Community Arts, Liverpool Institute for the Performing Arts, Mount Street, Liverpool L1 9HF, contact: Nick Owen. From September 1995 LIPA will provide training in community arts within an intergrated degree structure. Aims to develop student's facilitation skills togeher with the practice of their medium. Students work with managers, technicians, designers and performers to equip them with variety of performing and workshop skills, groupwork and leadership skills and expertise to deliver community-based projects from inception to evaluation.

Grants/advice

Foundation for Sport and the Arts, PO Box 20, Liverpool, L9 6EA, tel: 0151 524 0235, contact: 0151 524 0285. Offers support to individual artists based on project proposals.

Marks & Spencers, Michael House, Baker Street, London, W1A 1DN, tel: 0171 935 4422, contact: Elizabeth Callender (Community Affairs Manager).

Information

Arts for Health, Manchester Metropolitan University, All Saints, Manchester M15 6BY, tel: 0161 236 8916. Gives advice and information on health care arts projects.

Community Development Foundation, 60 Highbury Grove, London, N5 2AG, tel: 0171 226 5375. Set up in 1968 to pioneer new forms of community development, CDF strengthens communities by ensuring the effective participation of people in determining the conditions which affect their lives through influencing policymakers, promoting best practice, and providing support for community initiatives.

National Association for Gallery Education, 8 De Montfort Road, Lewes, BN7 1SP, tel: 01273 478692.

Unit for the Arts and Offenders, CRSP, Department of Social Sciences, Loughborough University, Loughborough, LE11 3TU, tel: 01509 223374.

Professional associations

Community Arts Forum, 81-87 Academy Street, Belfast, BT1 2JS, Northern Ireland, tel: 01232 242910, fax: 01232 312264. Established in 1992 as a coordinating body for all community arts groups across Belfast, which will extend to cover all of Northern Ireland. Membership of over fifty groups, CAF's role is central. As well as establishing a community arts database, developing training and workshop programmes, it will aid development of community arts in areas previously lacking them, organising large-scale events, developing video and publication projects, and establishing apermanent community arts theatre and resource centre in Belfast. CAF publish the magazine CAN.

National Association for Gallery Education, 8 de Montfort Road, Lewes, BN7 1SP, tel: 01273 478692.

Voluntary Arts Network, PO Box 200, Cardiff, CF5 1YH, tel: 01222 395395. Describes its mission to "promote participation in the arts." Aims to support those participating in the arts and encourage others; celebrate cultural diversity and increase equality of opprtunity; promotes role arts has in enhancing health and well-being of individuals and communities.

Public art agencies

Art in Partnership, 233 Cowgate, Edinburgh, EH1 1NQ, tel: 0131 225 4463, contact: Robert Breen. Deals with public art and commissions, providing opportunities for artists in Scotland and elsewhere.

Artangel Trust, 133 Oxford Street, London, W1R 1TD, tel: 0171 434 2887, contact: Michael Morris/ James Lingwood. Originates and promotes temporary and non-gallery based work which addresses social and political issues.

Artists' Agency, 18 Norfolk Street, Sunderland, SR1 1EA, tel: 0191 510 9318, contact: Lucy Miton/ Esther Salamon. Establishes residencies and placements for artists, writers, musicians and other practitioners in a variety of settings in the North of England.

Artpoint, Great Barn, Parklands, Great Linford, Milton Keynes, MK14 5DZ, tel: 01908 606791. Initiates and manages residencies and commissions in public settings in the East Midlands as well as providing consultancy.

Cardiff Bay Arts Trust, Pilotage House, Stuart Street, Cardiff, CF1 6BW, tel: 01222 488772.

Commissions East, 6 Kings Parade, Cambridge, CB2 1SJ, tel: 01223 356882.

Cywaith Cymru/Artworks Wales, 2 John Street, Cardiff, CF1 5AE, tel: 01222 489543.

Health Care Arts, Pegasus House, 37/43 Sackville Street, London W1X 2DL

Health Care Arts (England & Wales), 10 Clarendon Road, Leeds.

Health Care Arts (Scotland & Ireland), 23 Springfield, Dundee, DD1 4JE, tel: 01382 203099, contact: Elizabeth McFall. Develops visual arts in health care facilities.

Independent Public Arts, 25 Greenside Place, Edinburgh, EH1 3AA, tel: 0151 558 1950, contact: Jonathon Colin/Juliet Dean. Developing permanent and temporary public art projects in Scotland.

Public Art Commissions Agency, Studio 6, Victoria Works, Vittoria Street, Birmingham, B1 3PE, tel: 0121 212 4454, contact: Vivien Lovell. Initiates public art projects for private and public organisations which include residencies and commissions. Register of artists held on computer.

Public Art Development Trust, 3rd Floor, Kirkman House, 12-14 Whitfield Street, London, W1P 5RD, tel: 0171 580 9977, fax: 0171 580 8540, contact: Sandra Percival. Encourages and initiates public art projects for public and private bodies, developers, architects and individuals.

Public Art Swindon, Thamesdown Borough Council, Euclid Street, Swindon, SN1 2JH , tel: 01793 493196.

Public Arts, 24 Bond Street, Wakefield, WF1 2QP, tel: 01924 295791, contact: Graham Roberts. Organises public art projects, residencies and commissions in Yorkshire.

14 • Further reading

Afterimage

'Evangelical Aesthetics', Grant Kester, *Afterimage*, January 1995. Expanded version of talk given at Littoral conference in Salford 1994. Analyses the new public art and emerging institutional and ideological identity of the public artist, in relation to changes in arts patronage, current 'moral economy' of capitalism, and historical development of preogressive urban reform in USA.

'The US Project: Challenging the pedagogies of empowerment', Mathew Sommerville, *Afterimage*, October 1983. Discusses Sommerville's approach working with a youth media programme in El Cerrito, California, making tapes for local cable access station. Explores his experience in reference to cultural theory.

AN Publications

Available from: PO Box 23, Sunderland SR4 6DG. Tel 0191 514 3600, fax 0191 564 1600. Postage £1 per order.

Art in Public: What, why and how, ed. Susan Jones, 1994, ISBN 0 907730 18 3. Combines coverage of the contemporary context for public art with critical examination of projects and practical advice. Price: £9.85.

Artists Newsletter. Monthly magazine for artists, makers and photographers, lists commissions and other opportunities in the UK and abroad with news about a range of visual arts and crafts projects and practical and discursive articles. Price: £19.95 UK annual subscription (individuals), £28 (institutions).

Copyright, Roland Miller, 1991, ISBN 0 907730 12 4. Includes advice on copyright and moral rights in exhibitions and promotional material, royalty and licence agreements and copyright abroad. Price: £7.25.

Fact Pack: Insurance, 1994. Comprehensive information on artists' insurance needs. Price: £1.85 inc post.

Fact Pack: Rates of Pay, 3rd edition, 1994. Digest of fees and rates of pay for visual artists for commissions, residencies, workshops and exhibitions plus how to work out hourly rates and cost one-off items. Price: £1.85 inc post.

Fact Pack: Slide Indexes, 3rd edition, 1994. Listing 40 indexes and registers nationally, with details of eligibility and who consults them. Price: £1.85 inc post.

Making Ways: the visual artist's guide to surviving and thriving, 3rd edition, ed. David Butler, 1992, ISBN 0 907730 16 7. Covers exhibiting, selling, working in public and with people, collective action, skill sharing, publicity and promotion, studios, health and safety, employment and legal issues, insurance, contracts and copyright with reading and contacts lists. Price: 11.99.

Residencies in Education – Setting them up and making them work, Daniel Dahl, ed. Susan Jones, 1990, ISBN 0 907730 09 4. Case-studies and information section covering contracts, insurance, health & safety, training, resources, rates of pay for artists, arts organisations and funding. Out of print.

Art Monthly and Thames & Hudson

Art within Reach, ed. Peter Townsend, ISBN 0 500 97315 6. Useful guide covering implications of artists working in the public arena with details of contractual arrangements and legal and copyright considerations. Out of print.

Artists Agency

Available from: Artists Agency, 18 Norfolk Street, Sunderland SR1 1EA. Tel 0191 510 9318.

Living Proof: Views of a world living with HIV and AIDS, Nicholas Lowe and Michael McMillan, 1992, ISBN 0 9509 7972 4. Record of a photography and writing residency in North East England 1991-92. Outlines the artists' working processes as well as discussing AIDS, HIV and art. Majority of work reproduced is by non-trained artists. Price: £10 plus £1.50 post.

Placements: an information pack, 1990. Price: £2.25 inc post.

Arts Council of England

Available from: Arts Council of England, 14 Great Peter Street, London SW1P 3NQ. Tel 0171 333 0100.

Art for Whom?, ed. Richard Cork, 1978. Exhibition catalogue from Serpentine show curated by Richard Cork, then editor of Studio International. Aimed to "explore recent attempts to relate art to issues of social concern." Features Conrad Atkinson, Peter Dunn and Lorraine Leeson, Greenwich Mural Workshop, Stephen Willats, David Cashman and Roger Fagin. Cork's position then was impassioned and polemical. Needless to say it drew some criticism from the art world at the time and created some interesting debate before dissapearing again off the agenda.

Arts Council Directory of Media Education Resources, ed. Margaret O'Connor, Dianne Bracken, 1992. Lists sources of books, slide packs, videos and films for classroom use. Price: £10.95 inc postage. Alvailable from: AN Publications, PO Box 23, Sunderland SR4 6DG tel 0191 514 3600.

Cultural Grounding: Live Art & Cultural Diversity (Discussion Paper), Michael McMillan, 1990.

Live Art in Schools, Richard Layzell, 1992. Both practical advice and philosophical background, from one artist who has 'done it', for teachers and artists. Includes a brief and intersting history from DADA, through happenings and performance to 'live art'. Price: £2.99 plus £1 post. Available from: AN Publications, PO Box 23, Sunderland SR4 6DG tel 0191 514 3600.

National Arts and Media Strategy, 1992. A number of the discussion papers relate to art with people: 'Community Arts', Lee Corner; 'A Plea for Poetry', John Fox; 'Towards a New Cultural Map', Paul Willis; 'Cultural Diversity'; 'Amateur Arts'; 'Disability Arts'.

Arts Council of Wales

Available from: South East Wales Office, Arts Council of Wales, Victoria Street, Cwmbran NP44 3YT. Tel 01633 875075

Artists in Residence 1984-94, 1994. Looks at ten years of residencies in South West Wales, featuring 25 artists. Price: £2 inc post.

Arts Development Association

A for Arts: Evaluation, Education and Arts Centres, Saville Kishner, 1989, ISBN 0 948861 05 3. Describes and assesses the evaluation which took place for 'The Magic Experience' and provides guidance for artists and administrators with evaluating their practice. ADA is no longer in existence but you'll find the book in good education libraries.

Banff Centre Press, Canada

Questions of Community: Artists, Audiences, Coalitions, 1995. Anthology with over twenty contributors sharing experiences and stategies in a range of Canadian contexts concerning dramatic changes underway in contemporary art world – stronger artist alliances, scepticism about institutions, awareness of new audiences. Includes analysis of term 'community' and role of audience in concept forming.

Bay Press, Seattle

Democracy: a project by Group Material, ed. Brian Wallis, 1990, ISBN 1047 6806. Covers many discussions of art and the potential it carries as a tool for discussing complex social issues and raising debate around democracy and human rights.

If you lived here: the city in art, theory and social activism, ed. Brian Wallis, 1990, ISBN 0 941920 18 6. Outlines artists' activities in the urban environment in America. The book is "a practical manual for community organising" and presents discussions on how artists and art can actively engage in developing "humane housing policy" and humane environments.

Mapping the Terrain: New Genre Public Art, 1995, ISBN 0 941920 30 5. Departing from traditional definitions of public art, brings artists into direct contact with audiences to deal with compelling issues of our time. First definitive collection of writings on the subject by critics, artists and curators who are pioneers in the field. Includes Lucy Lippard, Suzi Gablick, Geoff Kelly.

Bedford Square Press

Artists in Schools – a Handbook for Teachers and Artists, Caroline Sharp and Karen Dust, 1990, ISBN 0 7199 1262 8. Gives guidance to artists and teachers through each stage of a placement's life. It offers advice on evaluation, looks at working with special needs and multi-cultural projects and includes discussion on the role of artists in the professional development of teachers. Out of print.

British Film Institute

Available from: Plymbridge Distibutors Ltd, Estover Road, Plymouth PL6 7PZ. Tel 01752 695745.

Primary Media Education – a curriculum statement. Guide to teaching approaches in media education for primary teachers and costs. Price: £6.50 plus £1 postage.

Blackthorn Press

Street Video, Graham Wade, 1980.

Bloodaxe Books in association with Northern Arts

Available from: Bloodaxe Books, PO Box 1SN, Newcastle NE22 1SN. Tel 0191 232 5988

Under the Rainbow – writers and artists in schools, David Morley, ISBN 1 85224 112 8. Sets out good practice drawn from the Northern Arts region and from a two-day conference in 1988. Contains artists' and writers' experiences. Price: £4.99 plus 80p post.

Community Arts Forum

Available from CAF, 81-87 Academy Street, Belfast BT1 2JS. Tel 01232 242910.

CAN. Newsletter for the Community Arts Forum in Belfast. Includes news and profiles of groups and individuals, as well as more in-depth pieces.

Calouste Gulbenkian Foundation

Available from: Calouste Gulbenkian Foundation, 98 Portland Place, London W1N 4ET. Tel 0171 636 5313 Fax 0171 636 2948.

Manchester Hospitals' Arts Projects, Peter Coles, 1981. Price: £3 plus £1 postage.

Wanted! Community Artists, Rod Brooks, 1988. Deals with running training schemes for community artists. Price: £2.50 plus £1.50 postage. Available from: Turnaround Distribution, 27 Horsall Rd, London N5 1HR. Tel 0171 609 7836.

What the hell do we want an artist here for?, Sue Hercombe, ISBN 0 903319 411. Looked at artists working in industry including a background to the subject, company and artists meeting, the needs of industries, the artists' viewpoint and the part played by arts administrators. Price: £3.50 plus £2 postage. Available from: Turnaround Distribution, 27 Horsall Rd, London N5 1HR. Tel 0171 609 7836.

Centre for the Study of Comprehensive Schools

Available from: CSCS, University of York, Heslington, York YO1 5DD. Tel 01904 433240.

The Arts and the Education Reform Act 1988 – what teachers and artists need to know. Introduces National Curriculum, ways assessment is likely to take place and at what ages, links between artists and INSET courses, and possibilities for artists to work in schools. Lists strategic organisations and publications.

Comedia

Community, Art and the State: Storming the Citadels, Owen Kelly, 1984, ISBN 0 906890 35 7. Highly polemical and critically engaged, assesse the way community arts has developed and been shaped by funder's guidelines. Includes some pertinent analysis of the construct 'art', role of the state, and how certain community artists and activists collude with interests they are "allegedly seeking to change". Author "establishes the outline of a different strategy: one which would build upon the strengths of community art, but avoid the danger that community artists currently face of being licensed rebels whose very license makes them ineffectual." No longer in print but should be in good libraries.

Community Development Foundation

Available from: CDF, 60 Highbury Grove, London N5 2AG

Community Development and the Arts, Lola Clinton, 1994, ISBN 0 902460 82 7. Deals with 'The Importance of the Arts in Society', 'Action for Local Arts Development' and 'Creative Participation in Change and Development'. Other chapters on key issues around arts in the comunity and examples of good practice. Price: £3.95 plus 50p post.

Arts and Communities: Report of the National Inquiry into Arts and the Community, ISBN 0 902460 69 8. "Presents evidence of the breadth and sources of arts activities which play an increasing part in daily life and are valued for participation, building up communities and furthering a range of social issues." Assesses flux of change in local authorities and voluntary sector which has put the arts under more pressure. Asks what new policies, funding and support structures are required to sustain arts in the community, to find a collective voice and national influence. Concludes with eighteen recommendations which all artists working in these areas should become familiar with, if not have role in advocating for them. Price: £7.50 plus 75p post.

DHSS Health Building Directorate

Art & Healthcare, Linda Moss, ISBN 185195. Intended for artists and organisations, showing how the arts work for hospitals. Includes how schemes were set up, case studies including artists in residence, funding, sponsorship and bibliography. Price: £6.

Greenwich Mural Workshop

Available from: AN Publications, PO Box 23, Sunderland SR4 6DG. Tel 0191 514 3600. Postage £1 per order

Mural Manual, 3rd edition, Carol Kenna and Steve Lobb, ISBN 0 907730 03 5. Looks at the practicalities of setting up mural projects. Price: £5.40.

Murals in Schools, 2nd edition, Carol Kenna and Steve Lobb, ISBN 1 870100 05 0. Handbook for teachers on setting up mural projects in schools. Full

of straightforward, practical advice on developing ideas and getting them made, Price: £4.99.

Helen Crummy

Available from: Helen Crummy, 4 Whitehall Street, Newcraighall, Lothian EH21 8RA.

Let the people Sing: a Story of Craigmillar, Helen Crummy, 1992. "Told with warmth and humour", author "recounts from firsthand experience as a child, then a mother and activist, how Craigmillar quickly became a social disaster" and how "mothers, frustrated at the lack of educational, employment, social and cultural opportunities for the 25,000 inhabitants, founded the Craigmillar Festival Society... they came to question the environment their city had given them to live in and mounted numerous social action initiatives to improve the quality of their lives. The arts became a springboard for a revitalised community... where people came to have a say in the decision making affecting their lives." Derek Rodger.

High Performance

Available from: High Performance, 1641 18th Street, Santa Monica, CA 90404, USA.

'Alternate Roots and the Partnering of Artists and Communities', *High Performance*, Winter 1993. Special issue of this great and long-running magazine focuses on the processes of community-based art in collaboration with ROOTS (Regional Organisation of Theatres South). You should be able to find this in some art college libraries.

Inter-Action/Cassell

Video with Young People, Tony Dowmunt, 1987.

Kings Fund for London and The Forbes Trust

Available from: Engish Book Centre, PO Box 1496, Poole, Dorset BH12 3YD. Tel 01202 715555.

The Art of Dying, Crimmin, Shand & Thomas, 1989, ISBN 1 85551 048 0. Evaluates project when two artists spent ten weeks in residence in a hospice in Lancaster. Gives background to project, describes artists and how they were chosen, methods of evaluation, views and reactions plus assessments by staff, volunteers and other artists, and makes recommendations for the future. General guidelines are of value to others wishing to work in similar ways. Price: £8.50 inc postage.

Kirklees Media Education Forum

Available from: G Williamson, Curriculum Development Centre, Temple Road, Dewsbury, West Yorkshire WF13 3QD

Media Education Handbook. Descriptions of a range of media projects in schools. Price: £8.50.

Longman

Educating for Art: critical response and development, Rod Taylor, 1986, ISBN 0 582 36152 4. Presents case for developing critical awareness as well as practical skills in pupils and students taking art in schools. Arose from research of Critical Studies in Art Education project. Is of interest to all involved in teaching of art and gallery education.

Mailout

Available from: Mailout, 9 Chapel Street, Holywell Green, Halifax HX4 9AY. Tel 01422 310161. The only national magazine for "arts work with people". Covers a spectrum of activity. Each issue focuses on a different region, or is thematically-based. A delve into the back catalogue provides a comprehensive map of activities in the UK including listings of courses, book reviews, articles. Available only on subscription. Bi-monthly.

Media Education

Magazine published three times a year by RABs in the South and in East Anglia (see 'Contacts' for addresses). Lists courses, conferences, events, regional contacts, useful information plus reviews and articles. Price: Annual subscription £7.50 (individual) or £12.50 (institution).

Methuen

Engineers of the Imagination, 2nd edition, Tony Coult and Baz Kershaw, 1990, ISBN 0 413 52800 6. As much an historical survey of Welfare State as a "guide to the basic techniques of the company's work – making processions; large scale puppets and sculptures; fire and ice technology; shadow puppets; processional. theatre and dance music; celebratory food and feasts – set in context that explains the thinking behind the work". Price: £8.95.

Middlesex University

The Incidental Person – his art and ideas, John A Walker, 1995, ISBN 1 898253 02 1. First in-depth, scholarly study of John Latham's art and ideas. Explores negelected dimensions of the history of post-1945 art and discusses relation between art and science and the question 'is art superior to science in providing knowledge about reality?' Get an order into your local library.

Minority Arts Advisory Services

Available from: MAAS, 28 Shacklewell Lane, London E8 2EZ. Tel 0171 254 7275

Artrage. Magazine giving unique perspectives on marginalised areas of art practice and on minority arts develoment in in Britain. Contains articles, news and opportunities. Bi-monthly.

National Association of Arts Centres

The Magic Exercise, Victoria Neumark, 1989, ISBN 0 948861 03 7. Based on twelve case studies of projects run in arts centres. Offers practical insights into creative partnerships between education, arts centres and professional artists, musicians, dancers and actors. NAAC no longer exists, try libraries.

National Council for Voluntary Organisations

Schools and Voluntary Organisations – learning to work together, Jeanette Longfield and Nicky Parker, ISBN 0 7199 1190 7 (book) 0 7199 1196 6 (case studies). Based on case studies, this two-part publication offers guidelines for setting up projects between schools and the voluntary sector. Out of print.

London Voluntary Service Council

Available from: LVSC, 356 Holloway Road, London N7 6PA. Tel 0171 700 8107.

Voluntary but Not Amateur, Forbes, Hayes & Reason, 1990. Guide to the legal aspects of running a small organisation, including fundraising and accounting. Price: £12.95 inc pos.

National Foundation for Arts Education

Available from NFAE, University of Warwick, Westwood, Kirby Corner Road, Coventry CV4 7AL, tel 01203 524175

Artists and Schools, 1990. Anthology of projects from Arts in Schools schemes. Covers visual artists, verbal artists, textile artists and artists and cultural diversity. Final section includes description of the successful Wigan artists in schools scheme, some reflections on planning residencies, and raises a number of issues which need resolving in the future. Price: £5 inc post

The Future of the Arts in Schools, ed Andrew Worsdale, 1989. Report of the NCC Arts in Schools project's national conference at Warwick. Conference covered work of Arts in Schools project, arts and the National Curriculum, and looked at future strategies. Price: £1.50 inc post.

The Arts in Schools – principles, practice and provision, Ken Robinson, 1982 and 1989, ISBN 0 903319 23 3. Republished in 1989 with a new introduction. Is worthy of study by everyone concerned with the future of the arts in society. Out of this research came the Arts in Schools project 1985-1989. This subsequently became the National Foundation for Arts Education. Price: £6.

North West Arts

Available from North West Arts, 12 Harter Street, Manchester M1 6HY.

The Value of the Artist, 1988. A report on a conference held in 1988 by North West Arts, attended by art advisers, heads and teachers in Greater Manchester, which aimed to promote value of artists' work in schools and colleges. Conference speakers included artists and educationalists.

OUP

'Art Education Beyond Studio Practice', *Issues* magazine, 1993, special issue, vol 3, No 1, ISSN 09608648. Transcripts of conference at University of East London with contributions from David Harding, Peter Dunn and Malcolm Miles.

Pelican

Pedagogy of the oppressed, Paulo Freire, 1972, ISBN 0 14 022583 8. Discusses models of education which avoid the pupil teacher relationship, arguing for the developments of creative intelligence rather than the passive reception of information.

Pluto Press/ICA

Available from: ICA Bookshop, ICA, The Mall, London SW1Y 5AH. Tel 0171 930 05493.

Picturing the System, Conrad Atkinson, 1981. Survey of Atkinson's work 1970-81 covering projects dealing with industrial disease, multi-nationals, conflict in Northern Ireland, nuclear power, exploitation in Third World, racism and poverty. Contributions from Tim Rollins and Lucy Lippard. Although does not deal with art made with people, is essential reading for any artist conerned with form and content in issue-based work.

Prolific Pamphleteer

Invasion: a teaching resource for educators of young people, 1991. For educators of young people. Introduces issues surrounding personal and public health, security and defence in contemporary society.

Routledge

Artists and People, Su Braden, 1978, ISBN 0 7100 8920 1. Result of Gulbenkian Foundation commission looking at artists in residence schemes they set up 1974-76. Includes comparitive assessment of other developments in the field initiated by ACGB and RAAs. Written in accessible yet critical manner, with committment to subject and issues under examination. Author deals with context for art and relationship between artists, their work and "people who had not necessarily chosen or expected to come into contact with any art". No longer in print but should be in good libraries.

Distinction: A Social Critique of the Judgement of Taste, Pierre Bordieu, 1984, ISBN 0 415045 46 0. Theoretical in tone but fascinating nevertheless.

"The different aesthetic choices people make are all distinctions – that is choices made in opposition to those made by other social classes. Taste is not pure. The social world... functions simultaneously as a system of power relations and as a symbolic system in which minute distinctions of taste become the basis for social judgement." Price: £14.99. See below: Working Press, *Conspiracy of Good Taste*.

Timeshift: on video culture, Sean Cubitt, 1991. Argues video, rather than TV or film, has potential to become a uniquely democratic medium. Includes section documentary video such as miner's tapes and Despite TV.

Schools Curriculum Development Committee

Available from: Dramatic Productions Ltd, 79 London Street, Reading RG1 4QA. Tel 01734 394170.

Just like an artist, ed Mark Chapman. 17 minute video illustrating Suzanne O'Driscoll's work with 13-14 year olds during residency in a school. Useful for schools considering taking on an artist in residence. Price: £25 inc post.

Scottish Arts Council

Available from SAC, 12 Manor Place, Edinburgh EH3 7DO. Tel 0131 226 6051

'Community Arts', Charter for the Arts, Discussion Paper 23, Claire Higney. Other SAC discussion papers of interest cover Arts in Rural and Urban Areas, Gaelic Arts, Arts and Ethnic Minorities.

SHAPE London

The Art Works Report, 1987. Produced as result of course, for people with art training, to enable them to acquire skills in workshop techniques to use with community and special needs groups. Out of print.

Thames & Hudson

The Re-Enchantment of Art, Suzi Gablick, 1992, ISBN 0 500 23619 4. Doesn't deal specifically with art with people but does make well-developed, and very readable, arguments for a 'post-avant-garde' art that is 'useful' and socially commited, with new ways of engaging audience and issues. Develops a rather mystical aesthetic of 'lived reality' where artist/art/audience become a continuum. Price: £12.95

Valley and Vale

Available from: Valley & Vale, Blaengarw Workmens Hall, Blaengarw Road, Blaengarw CF32 8AW. Tel 01656 871911.

Creating Meaning: a book about culture and democracy, ed. Jerry Rothwell, 1992. Explains some of the issues raised by attempting to broaden participation in culture, through looking at development of Valley & Vale, chronicling it in the context of wider political issues.

Whitechapel Art Gallery

Available from: Whitechapel Art Gallery, Whitechapel High Street, London E1, tel 0171 522 7888.

Artists in Schools, 1989, ISBN 0 85488 084 4. Contains introduction to gallery's artists in schools programme which has been running since 1979. Includes essays and a list of all artists who've worked with the gallery. Price: £3.95 plus £1 post.

I can do that! Community Education at the Whitechapel, 1995, ISBN 0854 88107 7. Looks at the education schemes at the gallery with illustrations of particular projects. About to be published as this book goes to press so no details on price. Contact the Whitechapel for information.

Working Press

Available from: 85 St Agens Place, Kennington, London SE11 4BB.

Class Myths & Culture, Stefan Szczelkun, 1990, ISBN 1 870736 03 5. Collection of essays addressing issues of class and culture, with reports on three large-scale collaborative performance art events relating to urban communities. Price: £5.

Collaborations, Stefan Szczelkun, 1987. Asks if working class culture can produce serious art, with visual reports and original documents from the artist's collaborations. Price: £4.50.

The Conspiracy of Good Taste. Stefan Szczelkun, 1993. Wiliam Morris, Cecil Sharp and Clough William Ellis are scrutinised to begin to understand the mechanics of cultural oppression in various media. Includes an historical tracing of the history of good taste and a searing critique of Bordieu's sociological exposition. Price: £9.95. See also above: Routledge, *Distinction: A Social Critique of the Judgement of Taste*.

Youth Clubs UK Publications

Available from: Youth Clubs UK, 11 St Bride Street, London EC4A 4AS. Tel 0171 353 2366.

Kaleidoscope – arts work that works, ed Nick Randell and Simon Myhill, 1989, ISBN 090 7095 577. Describes range of arts in youth work settings in England. Makes suggestions on how to start projects and initiate training programmes in youth clubs. Price: £6.95 inc postage.

15 • Index

Page numbers in italics refer to illustrations.

PUBLICATIONS

Artists Handbooks

If you've found this book useful, why not check out the rest of the series? This steadily growing and well-respected portfolio of books deals with important aspects of visual arts practice now. Combining practical suggestions drawn from artists' own experiences with sound research and facts, these books are a unique resource, not only for visual artists at all stages of their careers and those studying art and design, but for arts organisers and officers, educationalists, careers and business advisers and all others involved with the arts.

Exhibiting & Selling Abroad

Judith Staines

Invaluable handbook for artists, makers and photographers who want to promote themselves and their work internationally, investigating everything from exhibitions and trade fairs to residencies and studio visits. With chapters on the practicalities of exporting work for sale, finding markets, sales administration and networking, *Exhibiting & Selling Abroad* also has plenty of examples of artists' and makers' own experiences.

PB, A5, 120pp, illus, ISBN 0 907730 21 3, £7.25

Fundraising

The artist's guide to planning and financing work

Ed. Susan Jones

Drawing on artists' first-hand experiences and advice, this book demonstrates the many ways in which artists and groups can finance exhibitions, travel, workspace, exploration and projects, ranging from grants from arts boards and charitable trusts to loans linked with business advice and from patronage to subsidised workspace. Showing how artists can mix and match sources, using one to lever another or combining several to realise large-scale projects, it is invaluable to artists, students, arts organisers and all others initiating and developing visual arts projects.

PB, A5, 134pp, illus, ISBN 0 90 7730 20 5, £7.25

an

PUBLICATIONS

Selling

Judith Staines

This much-needed book is for visual artists, crafts-people and photographers who want to sell their work. It doesn't explain how to get rich quick or teach slippery sales techniques, but does offer a realistic, supportive and practical approach to the business of selling. Using examples of how artists have promoted themselves and found markets for their work, *Selling* covers where and how to sell, pricing work and the fundamentals of administration and getting paid.

Whether you make decorative weavings, do abstract paintings on ceramics, create portraits or ephemeral installations, by adopting a proactive approach to selling and adding perseverance, imagination and a degree of good luck, it can be a profitable activity.

PB, A5, 136pp, illus, ISBN 0 907730 19 1, £7.25

Making Ways

The visual artist's guide to surviving and thriving

Ed. David Butler

Described by many artists as the most useful book they've ever bought, *Making Ways* covers everything from exhibiting to working in the community, from promotion to setting up a studio and from benefits to public art.

PB, A5, 256pp, illus, ISBN 0 907730 16 7, £11.99

Directory of Exhibition Spaces

Ed. Richard Padwick

A comprehensive guide to over 1600 galleries and exhibition spaces in England, Scotland, Northern Ireland and Wales, this is the third edition of an invaluable reference book for artists, makers and photographers seeking places to show and sell work, gallery organisers looking to exchange or tour exhibitions as well as for those wishing to find out where to see fine art, craft and photographic work.

PB, A5, 259pp, ISBN 0 907730 17 5, £13.99

Art in Public

What, why and how

Ed. Susan Jones

Essential reading for everyone interested or involved in art in public places, this timely book combines coverage of the contemporary context for public art with critical examination of projects and practical advice. By describing artists' experiences of permanent and temporary art, craft and photographic works in public locations, it is a valuable resource for artists wishing to initiate their own projects and work on an equal footing with other professionals.

PB, A5, 178pp, illus, ISBN 0 907730 18 3, £9.95

Live Art

Ed. Robert Ayers & David Butler

If your work involves live or temporary elements, this book is essential reading. Including advice on how to develop and manage a performance, touring, copyright, contracts and documentation and with numerous examples of artists' own experiences, *Live Art* is a must for all who want to perform, curate or promote live art.

PB, A5, 178pp, illus, ISBN 0 907730 13 2, £7.25

Money Matters

The artist's financial guide

Sarah Deeks, Richard Murphy & Sally Nolan

Reliable, user-friendly advice on taxation, National Insurance, VAT, keeping accounts, pricing, grants and dealing with suppliers, customers and banks. Features an excellent accounting system for all visual artists.

PB, A5, 134pp, illus, ISBN 0 907730 11 6, £7.25

Organising Your Exhibition

The self-help guide

Debbie Duffin

Frustrated by applying and being rejected by galleries? Here's a book which shows how to take control and organise your own exhibition. Covers finding and using alternative spaces plus costing, schedules, installation, publicity, selling and educational activities.

PB, A5, 116pp, illus, ISBN 0 907730 14 0, £7.25

Investigating Galleries

the artist's guide to exhibiting

Debbie Duffin

The question of how to get work seen by more than the cat and the gasman is answered in this book. Full of information and strategies to improve an artist's chance of exhibiting and minimise the risk of rejection and discouragement, it explains why artists need to investigate their own self-image, ambitions and long-term aspirations and have a clear understanding of how the art world operates before they embark on an exhibiting career. Sound advice on approaching galleries and presenting work, on sales commission, promotion and gallery education strategies means that artists who are young or isolated will find this book invaluable, and the more experienced will discover it inspires new approaches and a sharper plan of action.

PB, A5, 120pp, illus, ISBN 0 907730 221, £7.25

an
PUBLICATIONS

A response to the growing desire amongst artists and administrators to use sound legal agreements, our Visual Arts Contracts are ready to use and written in straightforward language. Each covers a special-ist area, either as easy-to-com-plete forms or as a point-by-point checklist with explanatory notes. Written by solicitor Nicholas Sharp, these contracts will ensure effective collaborations between artists, exhibition organ-isers, agents and commissioners.

Commission Contracts

By comparing public and private arrangements and describing the roles of parties in public art commissions, functions of agents and dealers and the implications of sub-contracting, it is an essential guide to good practice in an area which can be a minefield for artists. With fill-in contract forms covering Commissioned Design, Commission and Sale for Public Art, and Private Commission Contracts.
PB, A4, 20pp, £3.50

Introduction to Contracts

Outlines elements and terms in contracts, providing advice on how to negotiate, deal with disputes and find a solicitor.
PB, A4, 12pp, £1.50

Selling Contracts

Specifically concerned with selling art and craft work, this covers selling to private buyers, galleries and shops as well as contracts for sale or return.
PB, A4, 14pp, £3.50

NAA Public Exhibition Contract

Compiled by the National Artists Association – the representative body for visual artists – this covers showing work in public galleries and exhibition spaces and includes fees, sales arrangements, insur-ance, promotion, touring.
PB, A4, 24pp, £3.50

Licensing Reproductions

Explains in straightforward terms how to grant or obtain permission to reproduce artwork or designs including what licensing agreements to use, fees and royalties, negotiating and monitoring agreements.
PB, A4, 20pp, £3.50

Residencies & Workshops

An ideal companion to our newest handbook *Art with People*, this new contract demystifies the legal arrangements for artists' residencies in any kind of settings. The ready-to-use contract form for a Residency deals with having more than one partner in an agreement, and the Workshop contract can be adapted for many 'one-off' activities. Also contains notes on employment and tax, copyright, moral and reproduction rights.
PB, A4, 16pp, £3.50

Ordering details

For mail orders add £1 per order for postage (UK) £2 per order (Europe) £4 per order (Overseas). Telephone creditcard orders to 0191 514 3600, or write to: PO Box 23, Sunderland, SR4 6DG (prices quoted at March '95 are subject to change)